IMAGES
of Rail

GRAND CENTRAL
TERMINAL AND PENN
STATION

STATUARY AND SCULPTURES

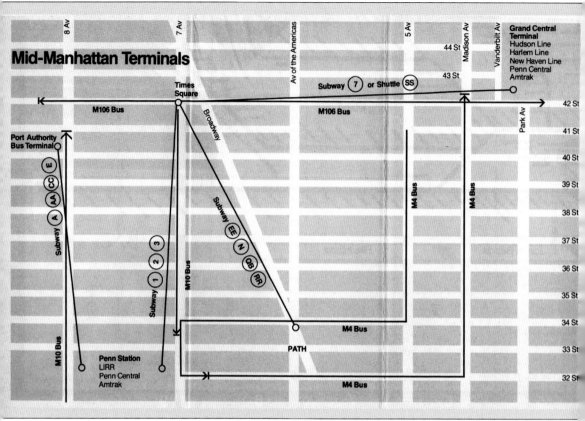

Mid-Manhattan Terminals

This diagram shows the locations of Grand Central Terminal and Penn Station on a Midtown Manhattan street grid. Grand Central Terminal is at upper right, while Penn Station is at lower left. The stations are slightly over one mile apart. A person desiring to travel on foot would walk from Penn Station north to Forty-Second Street, turn right, and walk east to Vanderbilt Avenue, where Grand Central Terminal would be on the left. (Courtesy of Metropolitan Transportation Authority.)

ON THE COVER: This is a view of the main facade of Penn Station shortly after it opened in 1910, looking west on Thirty-Second Street, with Seventh Avenue in front of the station. (Courtesy of the Library of Congress.)

IMAGES
of Rail

GRAND CENTRAL TERMINAL AND PENN STATION

STATUARY AND SCULPTURES

David D. Morrison
Foreword by Lorraine B. Diehl

ARCADIA
PUBLISHING

Published by Arcadia Publishing
Charleston, South Carolina

Printed in the United States of America

Library of Congress Control Number: 2018966761

For all general information, please contact Arcadia Publishing:
Telephone 843-853-2070
Fax 843-853-0044
E-mail sales@arcadiapublishing.com
For customer service and orders:
Toll-Free 1-888-313-2665

Visit us on the Internet at www.arcadiapublishing.com

This book is dedicated to Wayne Ehmann, who was the chief architect of the 1990s Grand Central Terminal restoration project. He left us too soon, but his legacy lies in the beauty of the world-famous landmark building. (Courtesy of Jeannie Ehmann.)

CONTENTS

FOREWORD

Symbols tell stories. In classical architecture, those symbols often took the form of statues that informed us of a building's function. In the case of New York City's two famous railroad stations, the clocks and the eagles gave us their story.

Railroads are governed by timetables, as are the passengers who use them, so it was fitting that Cornelius Vanderbilt's two Grand Central buildings and the present Grand Central Terminal that replaced them each had clocks atop their respective facades. The 13-foot clock adorning the present terminal is fashioned of Tiffany glass and is the centerpiece of French sculptor Jules-Felix Coutan's handsome trio of Roman gods. When Alexander Cassatt brought his monumental Pennsylvania Station into Manhattan, each of its four entranceways featured a clock, flanked by a pair of marble maidens. Sculptor Adolph Weinman named one of his maidens Day and gave her a garland of sunflowers. Her companion, Night, was shrouded in a veil and carried a sleep-inducing poppy. The groupings were there to assure us that Pennsylvania Station functioned through the day and into the night.

But it was those eagles that made the soul soar. A convocation of them, fashioned of iron with 13-foot wingspans, reigned atop the second Grand Central Depot for a short 12 years, flanking its four clock towers until the depot came down and they took flight. Twenty-two eagles perched atop Pennsylvania Station on either side of Weinman's marble maidens, creating a stirring reminder of Alexander Cassatt's conquest of the two rivers that had challenged his entry into Manhattan. When his monumental train station was demolished, they would become sought-after reminders of what had been taken from us.

Today, a pair of the original iron eagles are back atop Grand Central Terminal, adding historical continuity to the landmarked building. Of Pennsylvania Station's twenty-two eagles, two of them are penned behind an iron fence facing the Seventh Avenue entrance to Madison Square Garden. They look lost and misplaced, as if they are hoping for the return of the building they were meant to guard.

—Lorraine B. Diehl
Author, *The Late, Great Pennsylvania Station*

ACKNOWLEDGMENTS

Credit must be given to the two original "New York railroad station eagle chasers"—David McLane, who tracked down the Grand Central Station eagles in 1965, and Joan Amundsen, who documented the Penn Station eagles in the May 1972 issue of *Railroad* magazine. McLane passed away in 1986, but his son Denis has shared many of his father's photographs and stories with me. Amundsen has also shared information and photographs with me. Laurie Hawkes, who donated the Bronxville eagle to the Metropolitan Transportation Authority, made sure that the agency did not forget about my role in getting the eagle to Grand Central Terminal. Nancy Marks and her late husband, Edwin, invited me to their home for an "eagle party," which was one of my most memorable days in my years of eagle hunting. Margarete Flitsch contacted me to introduce the Penn Station eagle head "Albert" to the public. Lorraine B. Diehl and John Turkeli have shared a wealth of Penn Station knowledge with me. Wayne Ehmann and Don Quick allowed me to closely follow the Bronxville eagle restoration work.

I would like to thank the following people for sharing images and information: William Alfieri, Steve Allen, Richard Althaus, Lynn Applebaum, Gail Belmuth, Joel Berse, Jamieson Bilella, Patrick Cashin, Wes Cowan, Don Curran, Paul Curran, G.B. Daniell Jr., Carl Dimino, Rebecca Duffy, David Dunlap, Jeannie Ehmann, Steve Engelhart, Alan Engler, Frank English, Ann Foreman, Doug Griesemer, Nathaniel Guest, Bob Haddock, Roy Heisler, Robert Koenig, Dawn Kriss, Gavin McDonough, Ann McFerrin, Claire Michie, Dakin Morehouse, David Murdock, Ryan Murphy, Norm Newberry, Susan Newton, Tim O'Hearn, James Pavone, Elbertus Prol, Michael Robinson, Janice Rubin, Klaus Schmidt, Christine Sears, Tony Segro, Joanie Sheilds, Thomas Shomo, Lori Day Space, Parker Space, Robert Sturm, James Suhs, Thomas Tomaskovic, Harry Tucker, and Jane Willis.

Caitrin Cunningham of Arcadia Publishing provided valuable input and guidance.

Finally, I want to thank my wife, Diane, who had the patience to see my project through to completion.

All images are from my collection unless otherwise credited.

INTRODUCTION

David D. Morrison . . . a railroad historian who may know more about
the eagles of Pennsylvania Station and Grand Central Terminal
than anyone else on earth.

—David Dunlap, *The New York Times*

Grand Central Terminal and Penn Station have similar beginnings, yet they are a study in contrast. Both stations are located in New York City's Manhattan borough only a few blocks from each other. Each is a major railroad passenger station, yet the two not connected by rail, except for the New York City subway system. Each of the buildings were capped by magnificent statuary groups. That is about the extent of the similarities.

The major difference between the two stations is that the 1913 Grand Central Terminal building is still there, and the 1910 Penn Station building has been demolished. Also, Grand Central Terminal is a location where trains end their run and go no farther. Trains terminate at Grand Central and then make return trips. Penn Station, on the other hand, is a location where trains can run through. Trains do not necessarily terminate at this location.

Passenger train service into New York City started in 1832 when the Harlem River Railroad established a station in Lower Manhattan. In 1846, the Hudson River Railroad was founded by Cornelius Vanderbilt, who consolidated the two railroads and established a station in an area of Lower Manhattan known as St. John's Park. In 1854, the City of New York prohibited the operation of steam locomotives below Forty-Second Street. Train coaches had to be hauled by horses up to Forty-Second Street. This led to Vanderbilt deciding to build a large station building at Forty-Second Street between Lexington and Vanderbilt Avenues. That station, opened in 1871, was called Grand Central Depot.

In 1898, Grand Central Depot was renovated and expanded from a three-story building to six stories. Designed by architect Bradford Lee Gilbert, it had four towers with cast-iron eagle statues at the corners. That building, which became known as Grand Central Station, lasted only 12 years until 1910, when it was demolished to make room for the construction of the present Grand Central Terminal. Fortunately, most of the eagles were saved and scattered throughout various locations in the Northeast.

Grand Central Terminal is the third station building at the same location on Forty-Second Street. Opened on February 2, 1913, tracks of the New York Central and the New York, New Haven & Hartford Railroads arrive at the station from the north and terminate at that location. Designed by the architectural firms of Reed & Stem and Warren & Wetmore, Grand Central Terminal is still there today in its original beauty.

Unlike Grand Central Terminal, Penn Station had quite a different origin and fate. The Pennsylvania Railroad (hereafter referred to as the PRR) passenger trains terminated in Jersey City, where passengers would have to board a ferry to go across the Hudson River to Manhattan.

The PRR was determined to enter Manhattan directly by rail. To accomplish this objective, the PRR purchased the Long Island Rail Road, allowing it to have access to New York State. Land on Long Island was needed for the construction of a passenger car storage yard and servicing facility.

The PRR engaged in a massive construction project in order to bring its passenger trains into the city. It constructed two tunnels under the Hudson River, four tunnels under the East River, a huge power plant in Long Island City, a two-mile-long passenger car storage yard in the Astoria section of Queens County (Sunnyside Yard), the Hell Gate Bridge, and the biggest and most beautiful passenger station in west-side Manhattan—Penn Station. Designed by the architectural firm McKim, Mead & White, Penn Station opened to the public on September 8, 1910, when a Long Island Rail Road train departed the facility.

In the words of the late railroad historian Ron Ziel, Penn Station "was designed to last eight hundred years before major structural work would have been necessary." Sadly, the building was demolished in a little over 50 years in what *The New York Times* referred to as "a monumental act of vandalism." The building was demolished because the PRR sold it to a developer for the construction of a new Madison Square Garden arena. It was the destruction of Penn Station that led to the passage of the New York City Landmarks Law, which saved Grand Central Terminal from being destroyed.

Fortunately, most of the statuary and sculptures from Penn Station were removed and preserved, being scattered to various locations, mostly in the eastern part of the country.

This book will tell the story of the statuary and sculptures that are now at Grand Central Terminal, as well as the story of the cast-iron eagles from the 1898 Grand Central Station. Also told will be the story of the sculptures that are now at Penn Station and the statuary and sculptures that were saved and distributed to various locations, mainly on the East Coast.

The chapters will concern the following:

Chapter 1, Grand Central Terminal Statuary: There are actually three generations of "Grand Central" in New York City. The first building erected in 1871 on Forty-Second Street was three stories high and was called Grand Central Depot. That building was renovated and expanded to six stories in 1898, when it was called Grand Central Station. That building was demolished in 1910 to make room for the construction of Grand Central Terminal, which opened in 1913.

Chapter 2, Penn Station Statuary: Penn Station was opened in 1910 by the Pennsylvania Railroad, thus the name "Pennsylvania Station," albeit in New York City. This building covered two full city blocks and had statuary and sculptures on all four sides of the building.

Chapter 3, Statues of Railroad Presidents: There are three bronze statues that will be discussed. A statue of New York Central Railroad president Cornelius Vanderbilt is in front of Grand Central Terminal today. A statue of PRR president Samuel Rea is in front of Penn Station today, and a statue of PRR president Alexander Cassatt is now at the Railroad Museum of Pennsylvania in Strasburg, Pennsylvania.

Chapter 4, Grand Central Station Eagles at the Terminal: This chapter will start with a brief discussion about David McLane, who in 1965 discovered the whereabouts of the eagles that were removed from Grand Central Station in 1910. Two of those eagles that have been returned to Grand Central Terminal in recent years will be discussed.

Chapter 5, Grand Central Station Eagles at Other Locations: There are seven eagles in other locations in New York State: Philipse Manor, Centerport (two), Shandaken, Kings Point, and Cold Spring (two). An eagle is also in Sussex, New Jersey.

Chapter 6, Penn Station Eagles in New York State: There are two on the Seventh Avenue side of Penn Station/Madison Square Garden, two are at the US Merchant Marine Academy in Kings Point, one is at Cooper Union College, and one is at the Hicksville Long Island Rail Road (LIRR) train station.

Chapter 7, Penn Station Eagles in Other States: There are four on the Market Street Bridge in Philadelphia, Pennsylvania, and one at each of the following: Valley Forge Military Academy, Pennsylvania; Hampden-Sydney, Virginia, Washington, DC; and Vinalhaven, Maine.

Chapter 8, Moynihan Train Hall: Some of the statuary, sculptures, and other artifacts from the old Penn Station building might be placed at the former General Post Office Building, present-day James A. Farley Building, which is to be renovated to become part of Penn Station. The new facility will be named after former US senator Daniel Patrick Moynihan, who proposed expanding Penn Station into the Farley Building and obtained federal funding for the project.

This book may be looked upon as a 30-year personal odyssey. Upon moving to Hicksville in 1974, I became fascinated in seeing the Penn Station eagle at the Hicksville Railroad Station Plaza. As president of the Long Island Rail Road Historical Society (now defunct), I led the May 15, 1990, commemoration event celebrating the 25th anniversary of the dedication of that eagle.

Studying the history of the Hicksville eagle led to the quest of learning about the other eagles and statuary that were once on the old Penn Station building. By circumstance, studying the Penn Station eagles led to interest and study of the Grand Central Station eagles. I have seen and photographed the remaining eagles of both buildings. From Florida to Maine and out west to Kansas City, Missouri, I tracked down and visited all of the eagles. This book contains a representative sampling of the photographs I took during my 30-year hunt for the railroad station eagles.

My research has resulted in several significant events. I was the catalyst for the placement of two Grand Central Station eagles that are now at Grand Central Terminal. A previously unknown Grand Central Station eagle was "discovered" in Sussex, New Jersey. I informed the Smithsonian Institution of an error that was on a plaque next to the Penn Station eagle located at the National Zoo. The head of a Penn Station eagle was learned about when the owner of that piece contacted me. Errors and discoveries were part of the odyssey of the search for the railroad station eagles.

It is hoped that this book will give the reader an appreciation of the statuary and sculptures that are part of New York City railroad history. There is a lot of interesting history about the subject at www.trainsarefun.com/prrstationeagles/prrstationeagles.htm.

The bibliography at the end of this book also serves as a guide for those desiring to learn more about Grand Central Terminal and Penn Station.

One

GRAND CENTRAL TERMINAL STATUARY

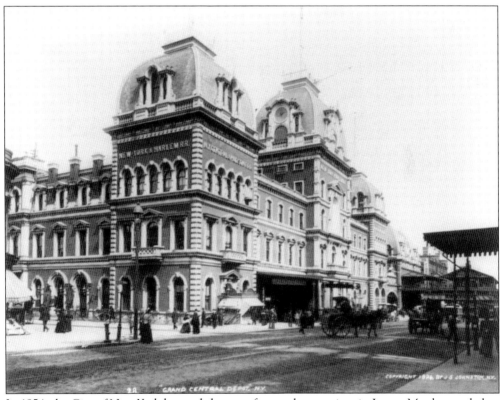

In 1854, the City of New York banned the use of steam locomotives in Lower Manhattan below Forty-Second Street, necessitating that trains below that point be pulled by horses. In 1871, Commodore Cornelius Vanderbilt, New York Central Railroad president, built a huge train station with frontage on Forty-Second Street, with Park Avenue meeting at its center. This 1890 image shows the building looking northeast, along Forty-Second Street. This building became known as Grand Central Depot. (Courtesy of the Library of Congress.)

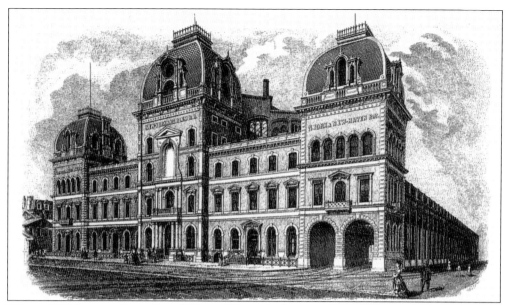

This c. 1871 drawing shows Grand Central Depot looking northwest. This building was divided into three sections, each serving three railroads: New York Central & Hudson River Railroad on the left, New York & Harlem Railroad in the middle, and New York & New Haven Railroad on the right. The depot opened on October 9, 1871, and was found to be ill-designed. Getting from one section to another was most inconvenient.

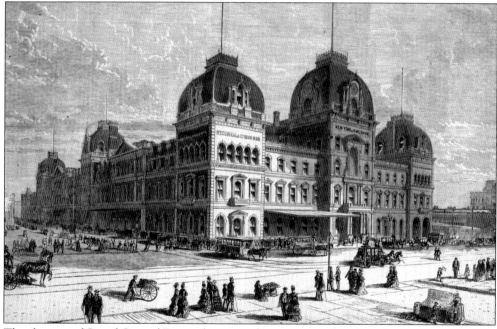

This drawing of Grand Central Depot, facing northeast, appeared in the February 3, 1872, edition of *Harper's Weekly*. The depot building was an L-shaped, three-story, redbrick structure. It took two years to build and was one of the most elegant buildings in the city. Five towers were on the building, with the Forty-Second Street center tower having large clocks on all sides. Trains entered and departed at ground level, heading north along what is now Park Avenue.

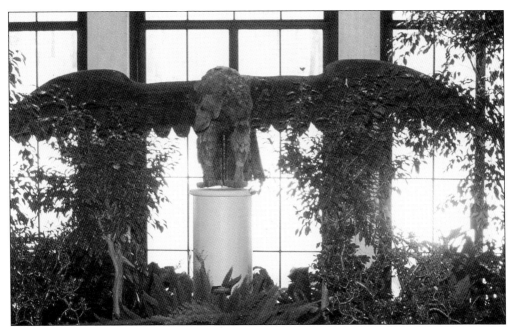

Located in the Winterthur Museum in Delaware is a 3-foot-high wooden eagle sculpture with a 14-foot wingspan. For decades, museum records identified this sculpture as being "from the first New York Central Railroad station in Manhattan." This photograph was taken at the fifth-floor conservatory on February 13, 1997. An extensive search was unable to reveal any photographs or descriptions of this sculpture being at Grand Central Depot.

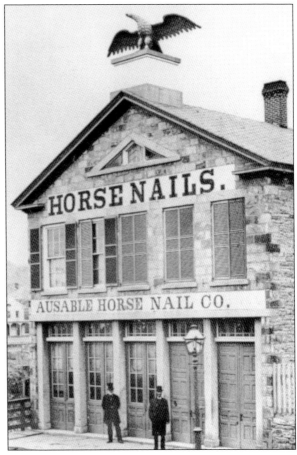

Recently, the Winterthur Museum has removed reference to Grand Central Depot from their object report and is now of the belief that the sculpture was originally on top of the Ausable Horse Nail Company building in Keesville, New York. This is an undated photograph of the wooden eagle on top of the building, which shows a striking similarity to the eagle at the Winterthur Museum. The building is still there, but the eagle is long gone, its fate unknown. (Courtesy of Steve Engelhart.)

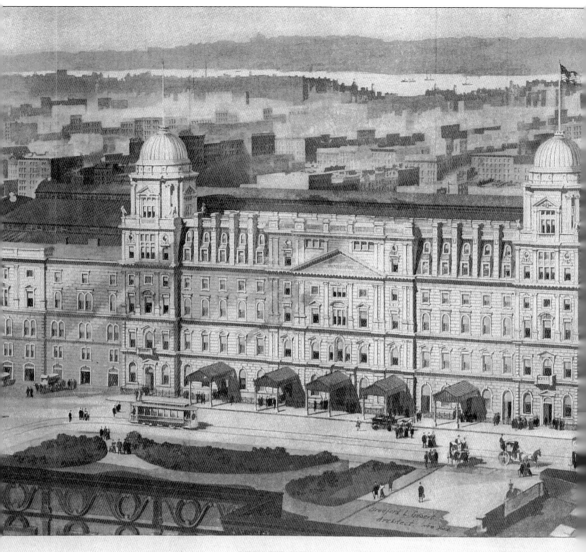

By the 1890s, Vanderbilt's railroads had grown and the depot was serving almost 500 trains per day. In the late 1890s, William Vanderbilt, who took over as railroad president when his father died in 1877, commissioned New York architect Bradford Lee Gilbert to design a renovation of the depot building. The three separate waiting rooms were combined into one large room, and three floors were added to accommodate the offices of the railroad's growing staff. Four towers were placed on the roof, with cast-iron eagle sculptures on the tower corners. The redbrick facing was

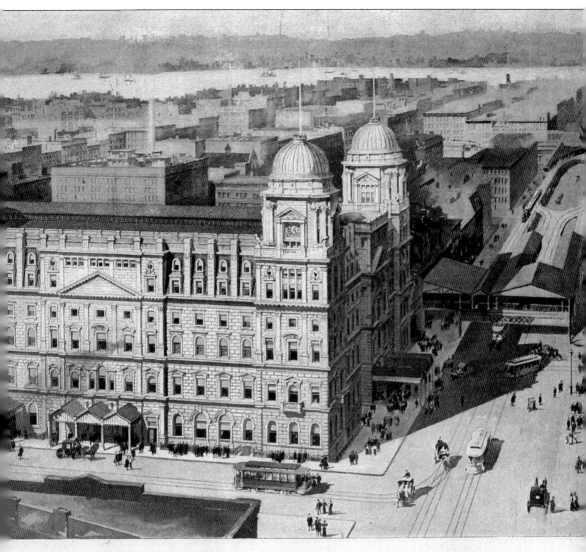

THE MANHATTAN HOTEL.

replaced with stucco, and the building took on an entirely different appearance. This drawing, with a view facing east, appeared in the February 5, 1898, edition of *Harper's Weekly* at the time of the opening of the renovated building. The street running from left to right is Vanderbilt Avenue, which runs into Forty-Second Street at right. This renovated structure became known as Grand Central Station.

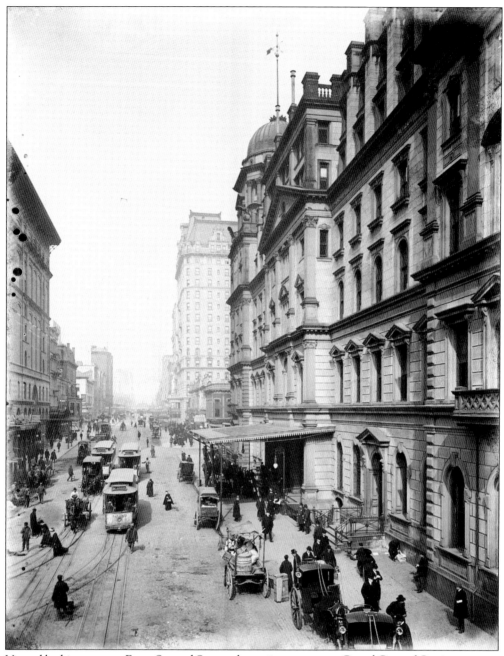

Viewed looking west on Forty-Second Street, the main entrance to Grand Central Station appears quite busy. Horse-drawn carriages and wagons, as well as trolley cars, are the vehicles of the day. The tower at the corner of Vanderbilt Avenue and Forty-Second Street can be seen, with two of the cast-iron eagles in view. (Courtesy of the Library of Congress.)

This photograph, taken from the corner of Park Avenue and Forty-Second Street, shows the tower with eagles at the corner of Vanderbilt Avenue and Forty-Second Street. The Manhattan Hotel is in the background. The second trolley in the foreground is being pulled by two horses. The horse-drawn carriages and trolleys connected the railroad passengers to the city, still concentrated to the south. (Courtesy of the Library of Congress.)

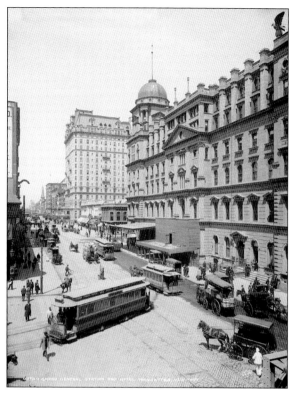

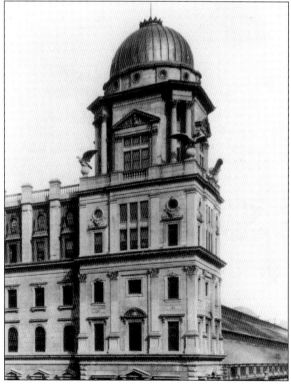

This is probably one of the best views of the cast-iron eagles as they adorned the station roofline. It is not known how many eagles were on the building, but the common estimates are 10 or 11. The sculptor is also a mystery. Some of the eagles faced forward, while others faced either left or right. (Courtesy of the Library of Congress.)

17

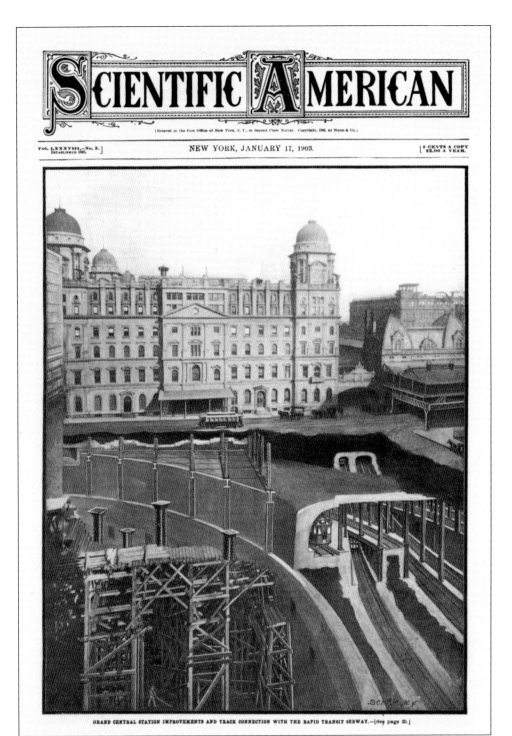

SCIENTIFIC AMERICAN

[Entered at the Post Office of New York, N. Y., as Second Class Matter. Copyright, 1903, by Munn & Co.]

Vol. LXXXVIII.—No. 3.]
Established 1845.

NEW YORK, JANUARY 17, 1903.

[5 CENTS A COPY
[$3.00 A YEAR.

GRAND CENTRAL STATION IMPROVEMENTS AND TRACK CONNECTION WITH THE RAPID TRANSIT SUBWAY.—[See page 39.]

The January 17, 1903, edition of *Scientific American* had a drawing of Grand Central Station on the cover, showing the underground subway tracks. The terminal of the Park Avenue spur of the Third Avenue elevated subway system is at right. Beyond the subway terminal is the 1885 annex to Grand Central Depot, which survived until 1910.

In 1901, the Pennsylvania Railroad started building tunnels and a huge railroad station on the west side of Manhattan. The New York Central Railroad, not to be outdone by the PRR, decided to replace the 1898 Grand Central Station building with a larger and more elegant structure. This drawing, which appeared in the June 17, 1911, edition of *Scientific American*, shows the proposed new building— Grand Central Terminal.

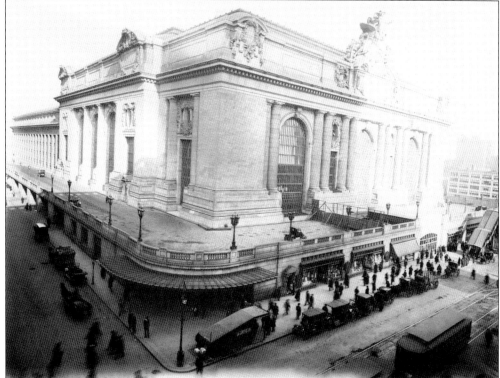

Designed by the architectural firms of Reed & Stem and Warren & Wetmore, Grand Central Terminal was of the Beaux-Arts style, opening on February 2, 1913. It was constructed on a 17-acre plot that required dozens of buildings to be razed. This photograph was taken shortly after the terminal opened, at a time prior to Park Avenue being elevated to go around the building. (Courtesy of the Library of Congress.)

19

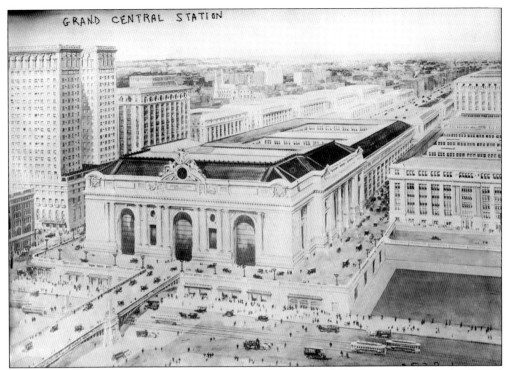

Viewed looking northwest, this image shows Park Avenue after it was raised, which allowed traffic to go around the building. It can be seen that the city north of Grand Central Terminal was devoid of any large buildings. The major population of Manhattan at this time was south of Forty-Second Street. North of the terminal, trains traveled south, under Park Avenue, to reach the terminal. (Courtesy of the Library of Congress.)

This view shows Grand Central Terminal from the corner of Vanderbilt Avenue and Forty-Second Street. Seen at right, the Park Avenue Viaduct opened on April 16, 1919, for the use of automobiles and taxi cabs only. The statue of Commodore Vanderbilt had not yet been placed at the base of the large, arched window in the center of the main facade.

Both photographs, taken facing north, show the Park Avenue Viaduct, also known as the Pershing Square Viaduct, as it reaches the front of the terminal and splits, allowing automobiles and taxi cabs to travel around the building, with northbound traffic at right and southbound traffic at left. The above view shows the New York Central Building that opened in 1928. Below, the Pan Am Building, opened in 1963, is seen behind the terminal with the New York Central Building behind it. The statue of Commodore Vanderbilt can be seen in front of the center window where Park Avenue splits. More about this statue appears in Chapter 3. (Both, courtesy of Metropolitan Transportation Authority.)

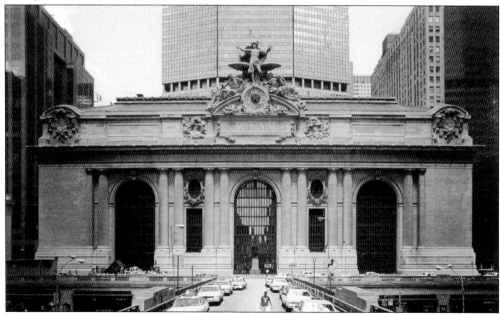

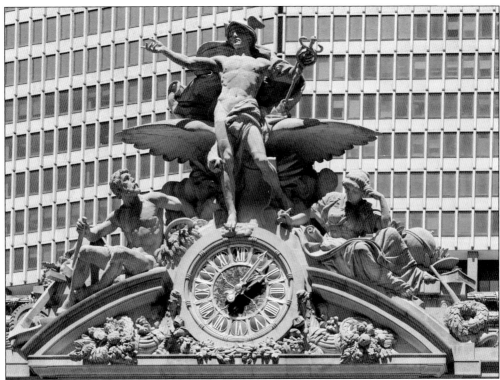

In 1914, a massive, 48-foot-high statuary group, weighing 1,500 tons, was placed on top of the south facade of the terminal. Designed by French sculptor Jules-Felix Coutan, this statuary was named *The Glory of Commerce* and consisted of three Roman figures: Mercury in the center, who was the god of speed; Minerva to the left, who was the goddess of wisdom and invention; and Hercules to the right, who symbolized physical energy. Behind Mercury, there is an eagle with spread wings and head bowed at Hercules's right knee. The limestone statuary was constructed from separate stones that were layered and cemented. The above view shows the Pan Am Building in the background, and the below view shows the statuary from above, taken from a building across the street. (Both, courtesy of Metropolitan Transportation Authority.)

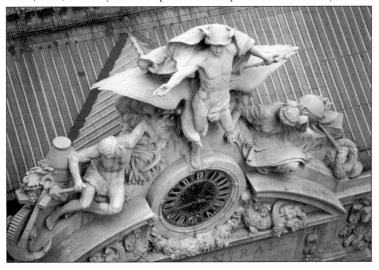

The huge size of the statuary is exemplified by this August 13, 1997, photograph showing the six-foot, three-inch author standing at the base. When this statuary was unveiled in 1914, it was considered to be the largest statuary group in the world. This photograph was taken by Metro-North Railroad electrician Gavin McDonough.

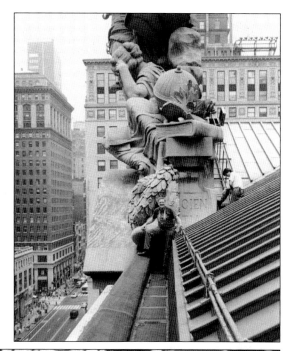

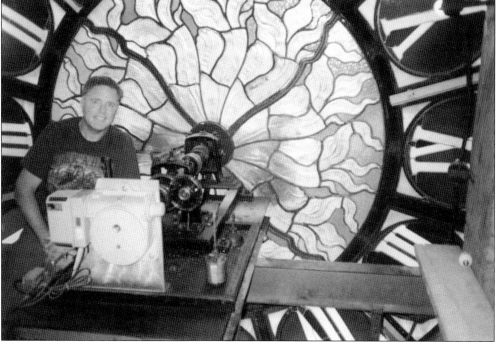

In the middle of the statuary group, there is a 13-foot-diameter clock, which is considered to be the world's largest example of Tiffany glass. The Roman numeral VI is a door that opens inward, allowing a view of Manhattan south—a view that few people ever get to see. The 100-pound hands of the clock are so perfectly balanced that they are moved by a tiny motor behind the clock, as seen in this photograph of the author next to the clock motor. This photograph was taken by Metro-North Railroad electrician Gavin McDonough.

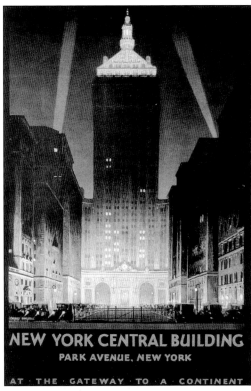

NEW YORK CENTRAL BUILDING
PARK AVENUE, NEW YORK
AT · THE · GATEWAY · TO · A · CONTINENT

In the late 1920s, the New York Central Railroad commissioned the architectural firm of Warren & Wetmore (which also worked on the design of Grand Central Terminal) to erect an office building for its ever-expanding staff. Located behind the terminal, this 34-story building opened in 1929 and became known as the New York Central Building. This poster shows the building looking south, down the middle of Park Avenue.

A statuary group with a clock in the center is over the Forty-Sixth Street entrance of the New York Central Building. Designed by Edward McCartan, this statuary presents a small-scale similarity to the statuary over the terminal. Mercury is at left, and the goddess Ceres is at right. The railroad sold the building in the 1950s, and it was later purchased by Harry Helmsley and renamed the Helmsley Building.

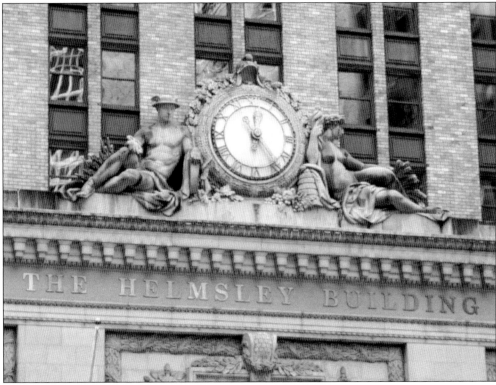

Two

PENN STATION STATUARY

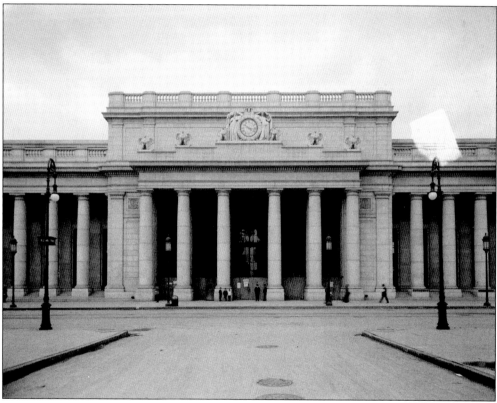

This is a view of the main facade of Penn Station looking west on Thirty-Second Street, with Seventh Avenue in front of the station. Designed by the architectural firm of McKim, Mead & White, the building opened on September 8, 1910, and was expected to last through the centuries. However, a scant 50 years later, it was demolished due to "the shortsighted acts of desperate men and the indifference of a sleeping city," as author Lorraine B. Diehl aptly stated. Today, Madison Square Garden stands where this great station once stood. (Courtesy of the Library of Congress.)

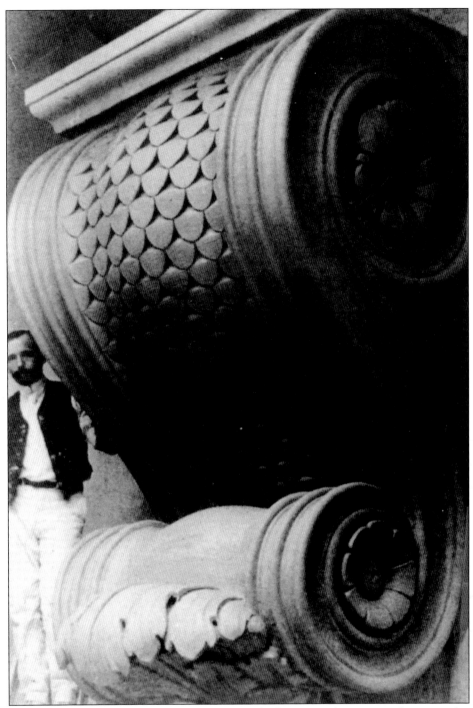

Sculptor Adolph Weinman stands next to one of the keystones that appeared in a number of places outside and inside the Penn Station building. Weinman designed the four statuary groups and the 22 eagles that adorned the four sides of the station exterior. He also sculpted the bronze statues of two PRR presidents that were inside the station. He was famous for designing US coinage, such as the Walking Liberty half-dollar. (Courtesy of Lorraine B. Diehl.)

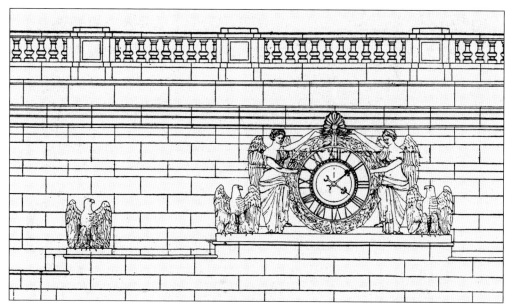

This drawing, which appeared in the July 14, 1906, edition of *American Architect and Building News*, was one of Weinman's earlier sketches of the Penn Station statuary. Note that in this drawing, the female figures sported wings and the eagles faced sideways toward the clock. The image of the final design below illustrates the differences, although a wreath still surrounded the clock and there was a decorative design at the top.

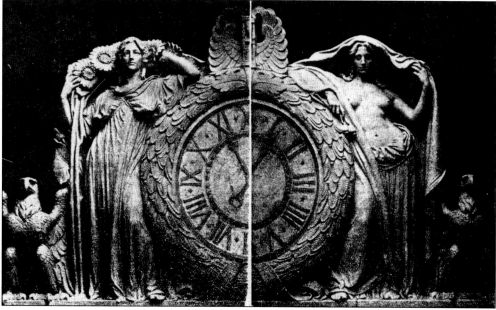

This photograph, which appeared in an edition of the *Monumental News*, shows the final design of the statuary group that was to be known as *Day and Night*. The figure of Day on the left was fully draped with sunflowers to the side of her head. The figure of Night on the right was draped and depicted pulling a cloth over her head. This article identified the quarry stone as being Knoxville marble.

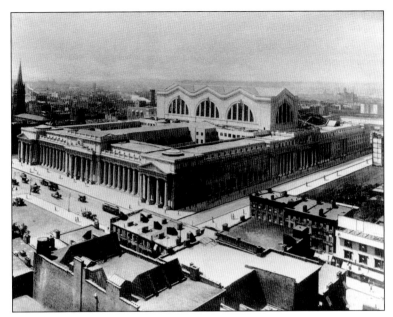

Viewed from Macy's department store, which opened in 1902, this scene shows Penn Station looking southwest at the corner of Seventh Avenue and Thirty-Third Street. Except for the church steeple at left, there are no tall buildings in the background. (Courtesy of the Library of Congress.)

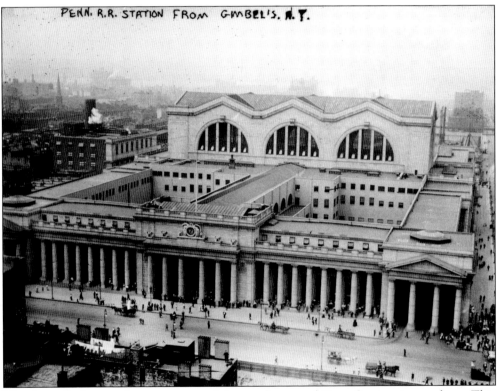

The Seventh Avenue front entrance of the newly opened Penn Station is seen here. This photograph was taken from the roof of the Gimbels department store, which opened in 1910, the same year that Penn Station opened. The elevated portion toward the rear of the building is the main waiting room. In the foreground is the property where the Pennsylvania Hotel would soon be built. (Courtesy of the Library of Congress.)

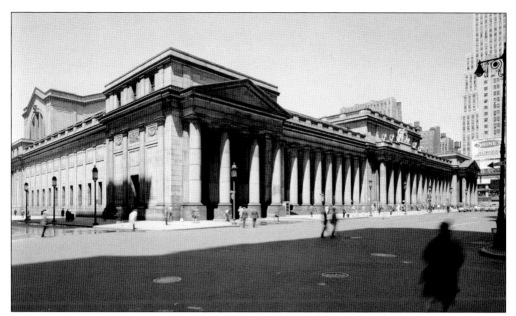

Looking north from the corner of Thirty-First Street and Seventh Avenue, the front of Penn Station can be seen in this c. 1910 photograph, with its fully-columnated facade, which stretched two full city blocks to Thirty-Third Street. There were 30 columns, with the main entranceway having six columns. On the north and south ends, there were porticoed carriageways, each having four columns. (Courtesy of the Library of Congress.)

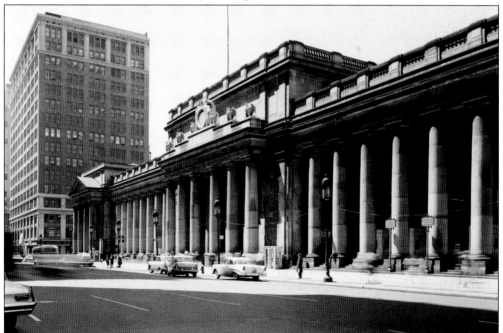

In this early 1960s view facing south, the station building was looking quite dirty from years of city pollution and lack of cleaning. The PRR simply did not have the funds to care for this beautiful building. Its days were numbered—both the building and the railroad. (Courtesy of the Library of Congress.)

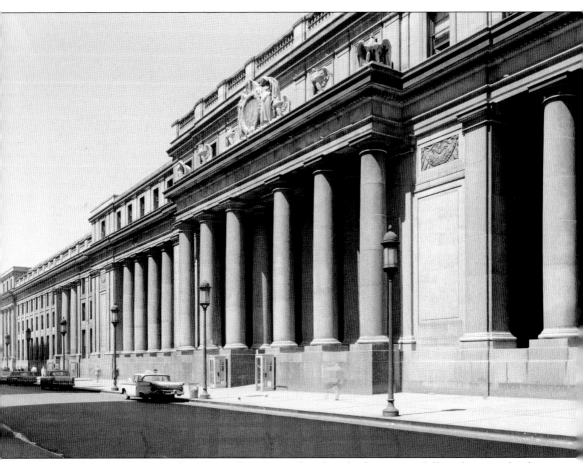

This photograph shows the Thirty-First Street facade, which was not fully columnated. The statuary group was quite similar to that on Seventh Avenue, with one major difference—the eagles at each end were on diamond bases rather than square bases. One of those eagles ended up at Cooper Union College in Lower Manhattan, while the other landed at the Smithsonian Institution's National Zoo in Washington, DC. (Courtesy of the Library of Congress.)

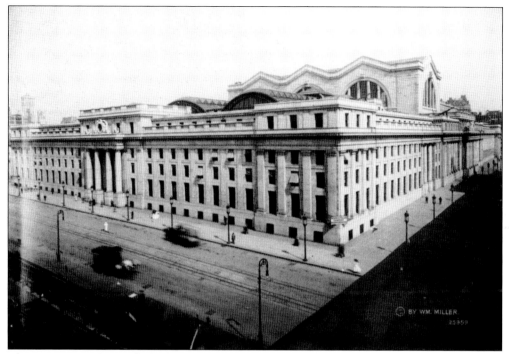

There were 22 eagles on the building, and each facade had 6 eagles, except that on Eighth Avenue, which is seen in both of these photographs. With only four eagles, the Eighth Avenue facade was certainly designed to make it look as though this was the "back door" to Penn Station. There were only four columns on this side of the building. In 1912, New York City's General Post Office Building was constructed across the street. (Both, courtesy of the Library of Congress.)

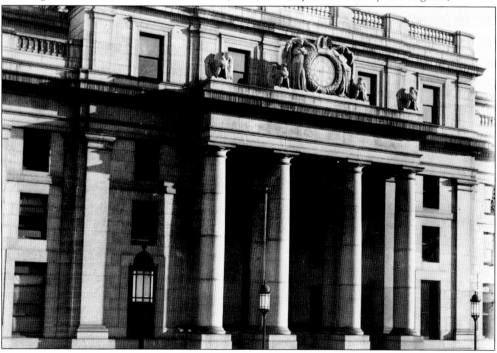

This 1936 photograph shows the Thirty-Third Street facade with the Greyhound bus terminal in the foreground. The statuary group was quite similar to the Seventh Avenue statuary group. This bus terminal building opened in 1935, and was demolished in the mid-1960s, shortly after the demolition of Penn Station. (Courtesy of the Library of Congress.)

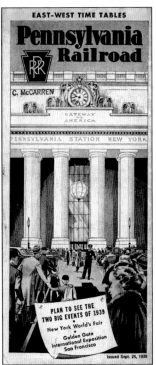

The PRR was quite proud of its Penn Station building in New York City and portrayed the main facade on many of its publications, such as stock certificates, advertisements, posters, and, in this case, the September 24, 1939, east-west timetable.

In this 1939 ad appearing in an issue of *National Geographic* magazine, the PRR promoted its service direct to the New York World's Fair. Penn Station was the central feature in the ad image, with the fairgrounds in the upper right. Service from Penn Station to the fair was provided by the Long Island Rail Road, which was part of the PRR system.

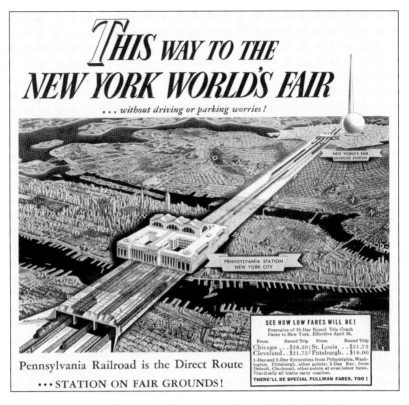

THIS WAY TO THE
NEW YORK WORLD'S FAIR
... *without driving or parking worries!*

NEW WORLD'S FAIR
RAILROAD STATION

PENNSYLVANIA STATION
NEW YORK CITY

Pennsylvania Railroad is the Direct Route
••• STATION ON FAIR GROUNDS!

SEE HOW LOW FARES WILL BE!
Examples of 30-Day Round Trip Coach
Fares to New York. Effective April 28.

From	Round Trip	From	Round Trip
Chicago	$28.20	St. Louis	$31.75
Cleveland	$21.75	Pittsburgh	$18.00

1-Day and 2-Day Excursions from Philadelphia, Washington, Pittsburgh, other points; 2-Day Exc. from Detroit, Cincinnati, other points at even lower fares. Practically all trains carry coaches.
THERE'LL BE SPECIAL PULLMAN FARES, TOO!

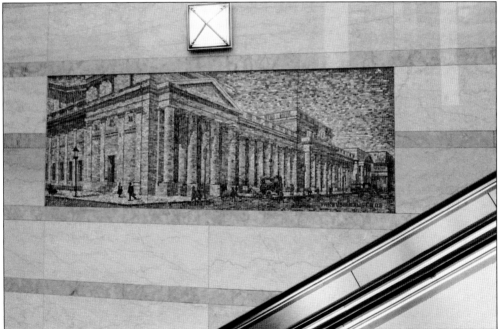

The beauty of the old Penn Station is portrayed today by a ceramic tile mural on a wall of the New Jersey Transit entrance to Penn Station. This is probably not the best location for such a nice piece of artwork due to the fact that it cannot be viewed up close.

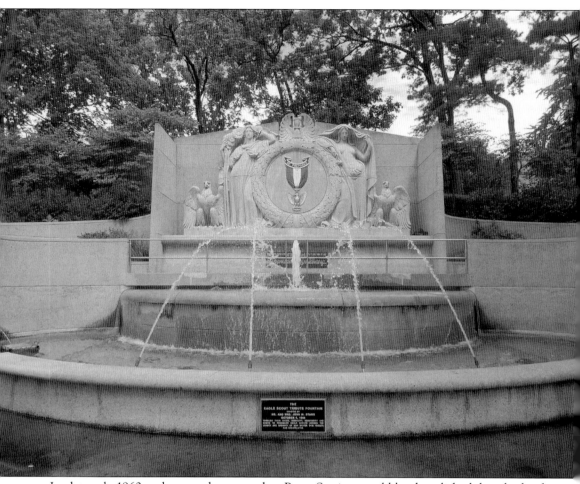

In the early 1960s, when word got out that Penn Station would be demolished, hundreds of letters were sent to PRR president Allen Greenough requesting statuary and sculptures from the famous building. Kansas City resident and former Boy Scout John W. "Twink" Starr wrote a letter requesting a full statuary group, stating that it would serve as a fitting tribute to the nation's Eagle Scouts. His request was granted, and the PRR shipped the statuary to Kansas City free of charge. The city donated land at the corner of Thirty-Ninth Street and Gillham Road, and Kansas City architect Maurice McMullen deigned the fountain in front of the statuary. A six-foot-high Eagle Scout badge replica was placed in the spot once graced by a large clock.

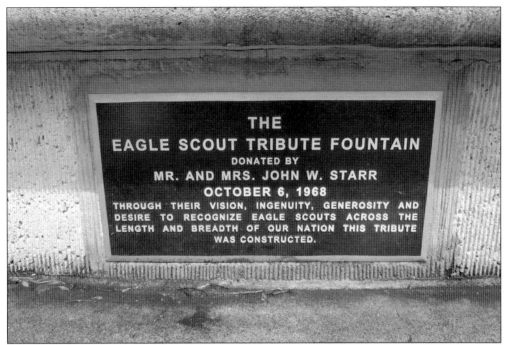

THE
EAGLE SCOUT TRIBUTE FOUNTAIN
DONATED BY
MR. AND MRS. JOHN W. STARR
OCTOBER 6, 1968
THROUGH THEIR VISION, INGENUITY, GENEROSITY AND
DESIRE TO RECOGNIZE EAGLE SCOUTS ACROSS THE
LENGTH AND BREADTH OF OUR NATION THIS TRIBUTE
WAS CONSTRUCTED.

On October 6, 1968, a ceremony was held dedicating the monument to the Eagle Scouts. These are the plaques that were placed on the fountain walls. The plaque above honored John W. Starr and Martha Jane Phillips Starr, who were responsible for obtaining the statuary and for funding the project. The plaque below credited Adolph Weinman for the design of the statuary. Though he donated the statuary, PRR president Allen Greenough's name was not included on either plaque.

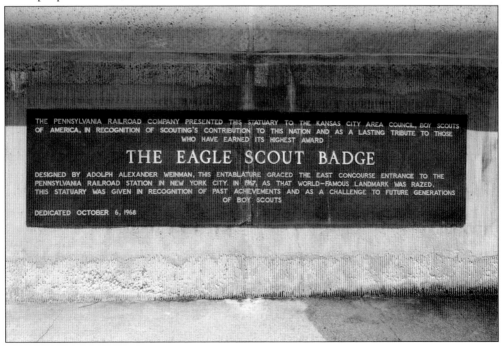

THE PENNSYLVANIA RAILROAD COMPANY PRESENTED THIS STATUARY TO THE KANSAS CITY AREA COUNCIL, BOY SCOUTS
OF AMERICA, IN RECOGNITION OF SCOUTING'S CONTRIBUTION TO THIS NATION AND AS A LASTING TRIBUTE TO THOSE
WHO HAVE EARNED ITS HIGHEST AWARD

THE EAGLE SCOUT BADGE

DESIGNED BY ADOLPH ALEXANDER WEINMAN, THIS ENTABLATURE GRACED THE EAST CONCOURSE ENTRANCE TO THE
PENNSYLVANIA RAILROAD STATION IN NEW YORK CITY, IN 1957, AS THAT WORLD-FAMOUS LANDMARK WAS RAZED.
THIS STATUARY WAS GIVEN IN RECOGNITION OF PAST ACHIEVEMENTS AND AS A CHALLENGE TO FUTURE GENERATIONS
OF BOY SCOUTS

DEDICATED OCTOBER 6, 1968

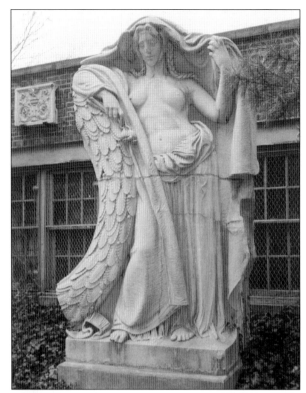

The figure of Night is at the Steinberg Family Sculpture Garden of the Brooklyn Museum. This piece was donated to the museum in the mid-1960s by Lipsett Demolition Company and Youngstown Cartage. The museum's records indicate that it was "carved in pink granite." However, the quarry stone was Knoxville marble.

In 1994, the Con-Agg Recycling Corporation in Bronx, New York, received a piece of statuary that it thought might be worth setting aside rather than breaking up for recycling—it was the top half of Day. Four years later, a photograph appeared in *The New York Times* showing a top figure of Day laying in the Meadowlands dump in New Jersey. The photograph was strikingly similar to the statuary at the recycling yard, and it is now on display there today, as seen here.

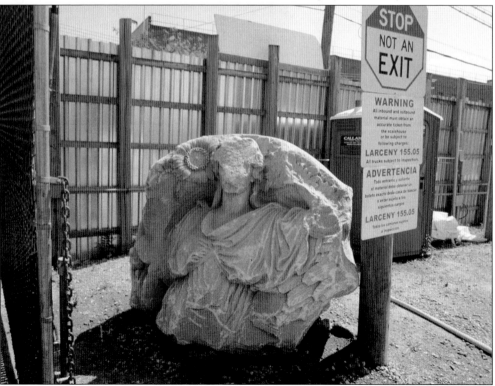

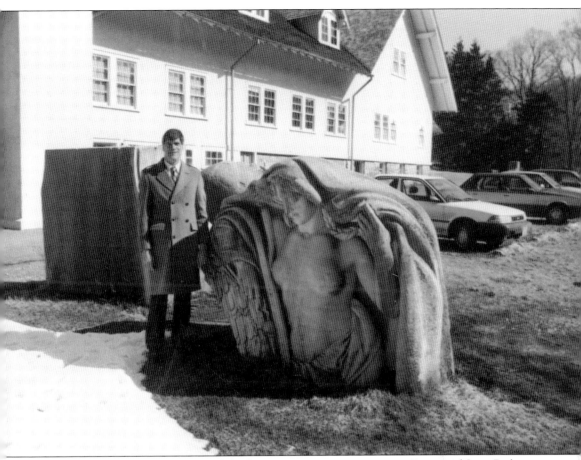

When Penn Station was being demolished, one statuary group was sent to Ringwood State Park in New Jersey. In March 1990, the author visited Ringwood and took this photograph of Ringwood Manor curator Bert Prol standing next to the top half of Night. More will be told about this statuary group in chapter 8.

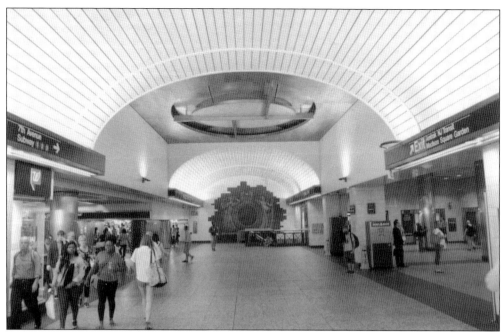

On June 8, 1990, the author, along with capital program manager Thomas Tomaskovic, submitted an LIRR employee suggestion recommending that the Ringwood State Park statuary group be placed at the far end of the LIRR concourse at Penn Station. The suggestion failed to generate results because it was estimated that $1 million would be needed to reinforce the floor to hold that amount of heavy stone. However, the suggestion was the catalyst for having a ceramic mural of the actual statuary installed instead. These photographs show the mural. Note there are no eagles. When asked about the absence of the eagles, the art studio replied, "Eagles were not in the photograph that we received." The mural does look nice, even though incomplete.

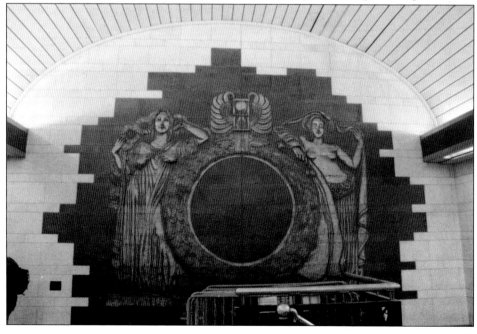

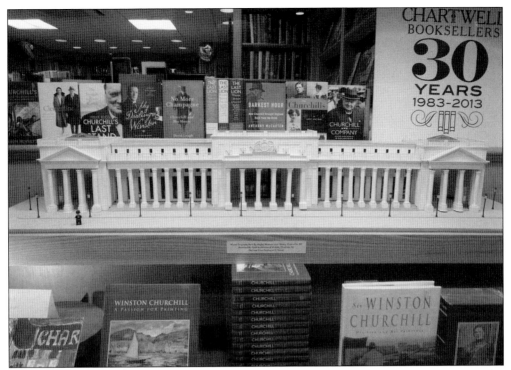

In 2004, a scale model of Penn Station, about 1/87th actual size, was on display at the Hagley Museum in Hagley, Delaware. The model, measuring 6 by 12 feet, was constructed by Chris Bear of the museum staff and about 20 volunteers, mostly retirees. The project was started in 1997 and was completed for the display at Hagley in 2004. The model is seen here when it was on display at Chartwell Booksellers in Manhattan. It is currently in storage.

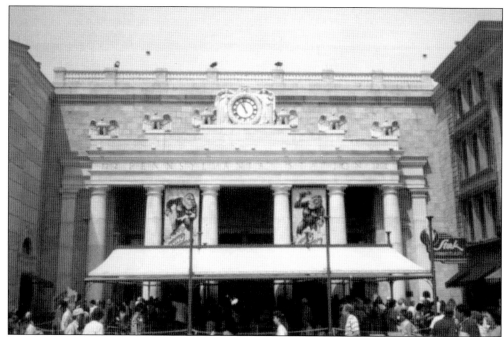

In the early 1990s, Universal Studios in Orlando, Florida, exhibited a miniature display (approximately 1/3 scale) of famous New York City buildings. One of them was Penn Station, measuring 110 feet long by 50 feet high. This miniature building was strikingly similar to the actual Penn Station, but the eagles had a wider wingspan. According to art director Norm Newberry, in designing Universal's exhibit, they were guided by drawings in Lorraine Diehl's book *The Late, Great Pennsylvania Station*, but they made the wingspans wider for dramatic effect. The display is no longer there, and its fate is unknown, according to a recent inquiry with Universal Studios.

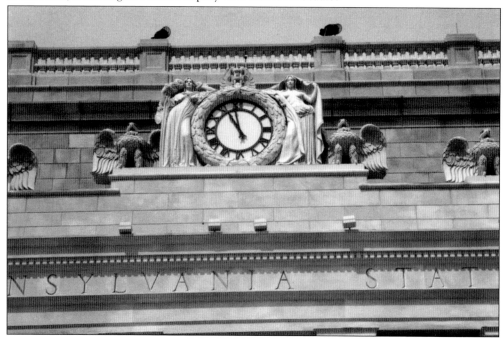

Three

STATUES OF
RAILROAD PRESIDENTS

Cornelius Vanderbilt started early in life operating ferryboats and steamboats, carrying passengers across the New York waterways. By age 45 (1839), he owned more steamboats than anybody else in the country, resulting in him being referred to as "Commodore Vanderbilt." During the 1850s, Vanderbilt took an interest in railroads, buying various ones that operated in New York State. In 1870, he consolidated his railroads into one of the biggest corporations in the country— the New York Central and Hudson River Railroad. He had Grand Central Depot finished in 1871, one of the most beautiful railroad stations in the world. He passed away in 1877 leaving most of his vast fortune to his son William.

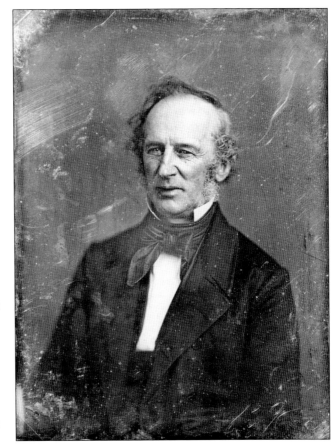

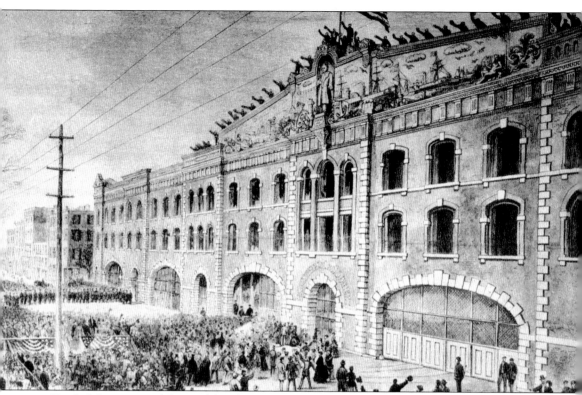

Vanderbilt recognized the need for a large freight facility in Lower Manhattan, so he purchased a tract of land in a section known as St. John's Park in 1867. The land was owned by Trinity Church, and Vanderbilt paid $1 million for transfer of the deed. He had a three-story building erected, the first floor to receive freight and the two upper floors for warehousing and office space. A huge bronze pediment, measuring 150 feet long by 31 feet high, was placed on top of the building. As seen in this illustration, a large crowd attended the dedication in November 1869.

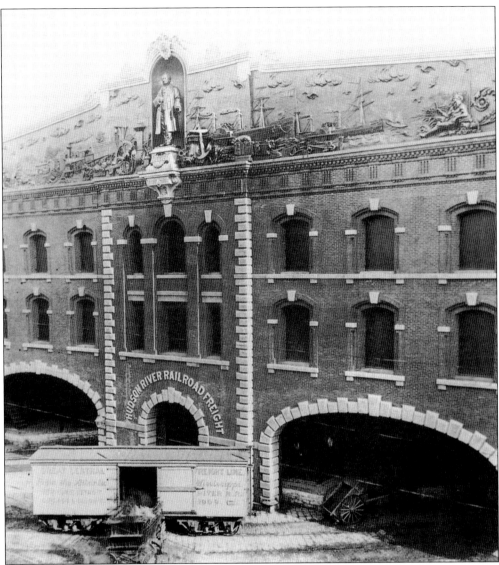

The bronze pediment, which cost $800,000, was sculpted by Ernest Plassmann. The piece had a statue of Vanderbilt in the center with bas-relief sculptures on each side. The artwork was designed to portray Vanderbilt's accomplishments in transportation. The left side portrayed his railroad achievements, and the right side depicted his nautical feats. The freight building was demolished in 1927, but the statue of Vanderbilt was taken away and placed at Grand Central Terminal in 1929. The fate of the bas-relief sculptures is unknown.

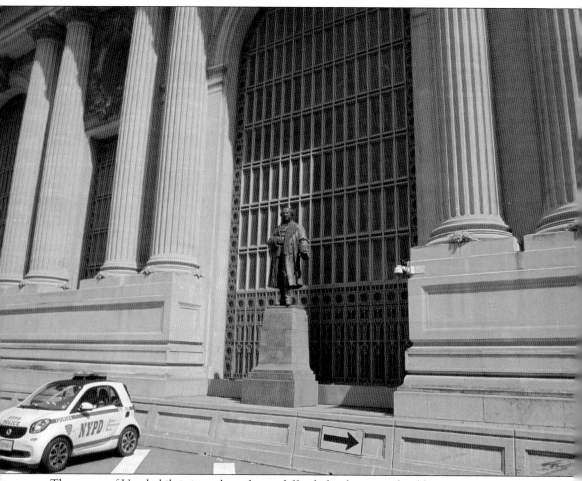

The statue of Vanderbilt is in a place that is difficult for the general public to view. It is located at the base of the middle window in front of the terminal, where Park Avenue splits and goes around both sides of the building. There is a walkway leading from the Grand Hyatt Hotel to the corner of Park Avenue. Pedestrians are not allowed to go farther. This photograph was taken from that location. The statue rests upon a nine-foot-high granite pedestal. Both the statue and the pedestal are well taken care of today by the Metro-North Railroad.

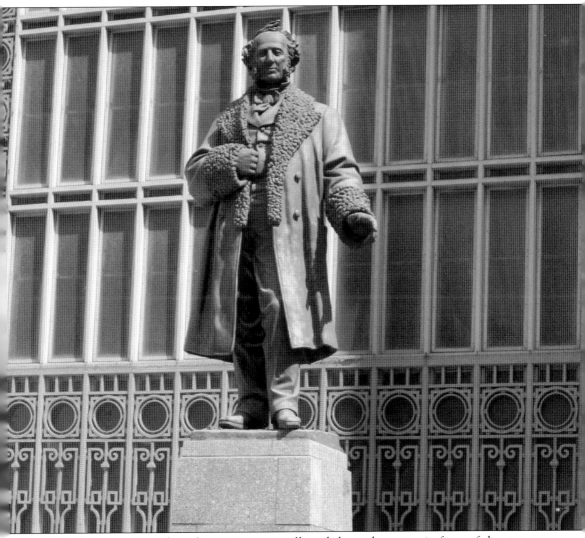

The policeman pictured on the previous page allowed the author to go in front of the statue to take this photograph. Vanderbilt's statue was sculpted in bronze and measures 8.5 feet high. Vanderbilt is portrayed in an expensive-looking leather coat with fur lapels and cuffs. Albert DeGroot, a close friend of Vanderbilt, commissioned the statue, and German-born American sculptor Ernst Plassmann designed the piece.

Alexander Cassatt was president of the Pennsylvania Railroad from 1899 until 1906, when he passed away while in office. Under his guidance and leadership, the New York extension of the PRR commenced. The project involved constructing two tunnels under the Hudson River, a huge passenger station in Manhattan, four tunnels under the East River, a huge coal-operated power plant along the bank of the East River, a massive passenger car storage yard in Long Island City, and eventually, a bridge allowing trains from New England to access Penn Station. Unfortunately, he died before seeing the project completed.

When Penn Station was completed, a statue of Alexander Cassatt was installed in a niche in the grand staircase that led from the arcade to the main waiting room below. The statue was there for all to see on the opening day of the station on September 8, 1910. The following words were inscribed at the base of the statue: "Alexander Johnston Cassatt / President Pennsylvania Railroad Company / 1899–1906 / Whose foresight, courage and ability achieved / the extension of the Pennsylvania Railroad System / into New York City." (Courtesy of John Turkeli.)

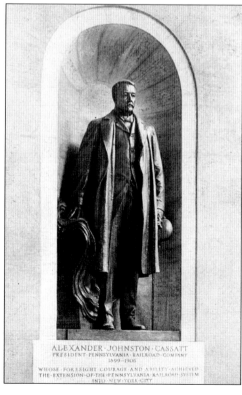

ALEXANDER · JOHNSTON · CASSATT
PRESIDENT · PENNSYLVANIA · RAILROAD · COMPANY
1899–1906
WHOSE · FORESIGHT · COURAGE · AND · ABILITY · ACHIEVED
THE · EXTENSION · OF · THE · PENNSYLVANIA · RAILROAD · SYSTEM
INTO · NEW · YORK · CITY

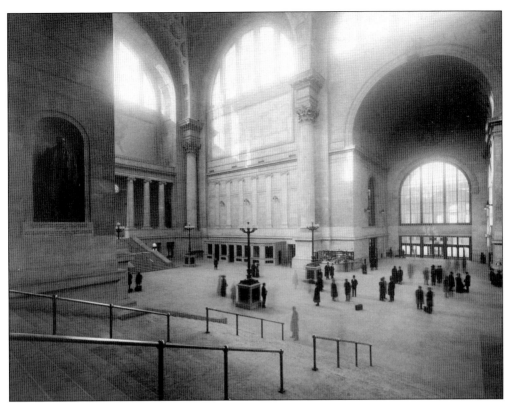

The statue of Cassatt is seen at left, near the base of the grand staircase leading down to the main waiting room. This staircase was 40 feet wide, and the main waiting room stretched the length of the building from Thirty-First Street to Thirty-Third Street, measuring 314 feet by 108 feet by 150 feet high. At the far right are the doors leading to the concourse where people would go to the appropriate gate and downstairs to their train.

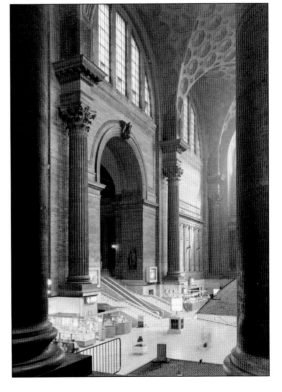

This view of the grand staircase shows the tall Corinthian columns on each side, with the Cassatt statue visible over the stairs. This photograph was taken after an escalator was installed in the center of the grand staircase.

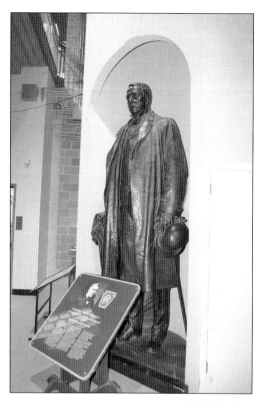

When Penn Station was demolished in the mid-1960s, the statue of Cassatt supposedly went to the Rensselaer Polytechnic Institute, which is where he graduated in 1859. Either it never went there or was rejected by the school, because it ended up at the Railroad Museum of Pennsylvania in Strasburg, Pennsylvania. It is nicely displayed indoors with a commemorative plaque. (Courtesy of Carl Dimino.)

The plaque, which obstructs the view of Cassatt's shoes, has a photograph and the PRR keystone emblem at the top with text pertaining to the statue. Unfortunately, the plaque names the sculptor as Alexander Weiner, which is a gross error. At the base of the statue, below Cassatt's shoes, the name of A.A. Weinman could have been seen, and the record set straight. The incorrect name probably was obtained from Cassatt's biography *End of the Line*. That author mistakenly named Weiner as the sculptor. (Courtesy of Carl Dimino.)

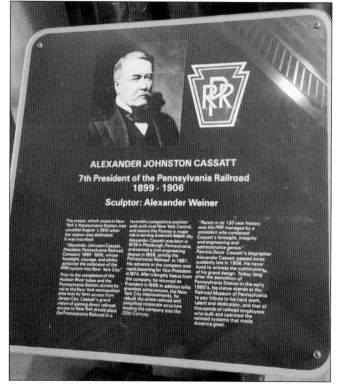

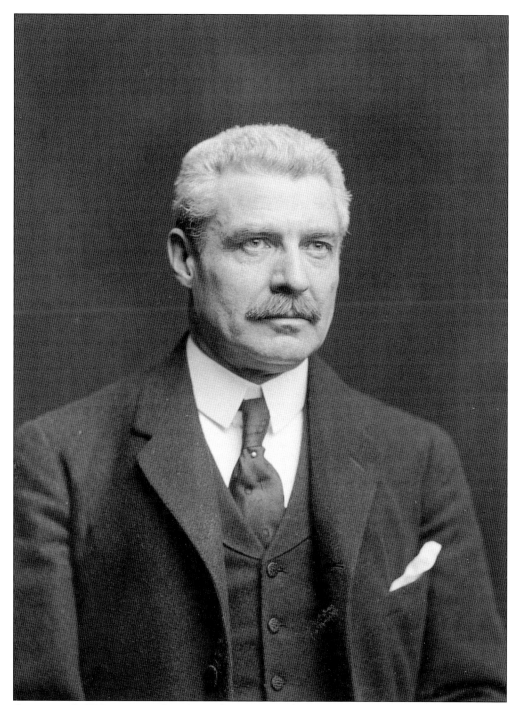

Cassatt made PRR vice president Samuel Rea responsible for the direction of the huge New York extension project that began in 1903 and was completed in 1910, albeit with the exception of the Hell Gate Bridge, which was not completed until 1919. Rea became PRR president on January 1, 1913, until retiring on October 1, 1925, under pension department rules.

A statue of Rea was installed in the niche opposite Cassatt's statue. It is seen at left at the top of the grand staircase. These escalators were installed during the 1940s. (Courtesy of John Turkeli.)

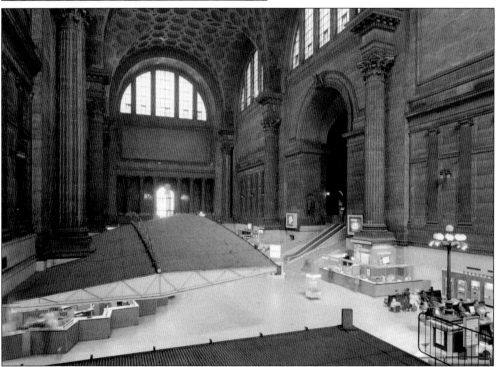

The Rea statue can be seen in the distance beyond the grand staircase. In 1956, the canopy was installed with ticket counters below. Created to add a more modern appearance to the waiting room, it blocks the entrance to the concourse, and many people thought it looked like a monstrosity. The station would last another decade before it was demolished.

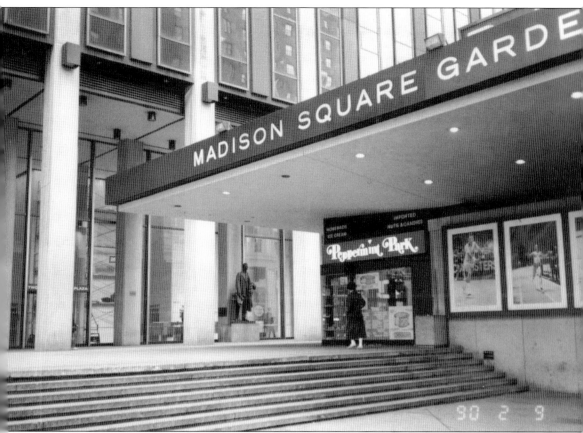

Fortunately, the Rea statue remained in New York after Penn Station was demolished. The 10-foot-high bronze statue was placed at the entrance to 2 Penn Plaza, which is outside the Madison Square Garden entrance. This photograph facing northwest shows the statue, which faces Seventh Avenue.

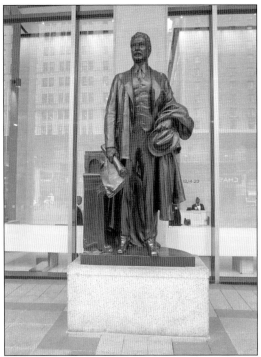

The Rea statue was designed by Adolph Weinman, as was the Cassatt statue and all of the statuary and sculptures in and on the station. Weinman's name is engraved into the bronze at the lower-left portion of the base. Rea holds his coat and hat in his left hand and a roll of plans in his right hand. At his right, slightly behind him, is a model of the Hell Gate Bridge facade.

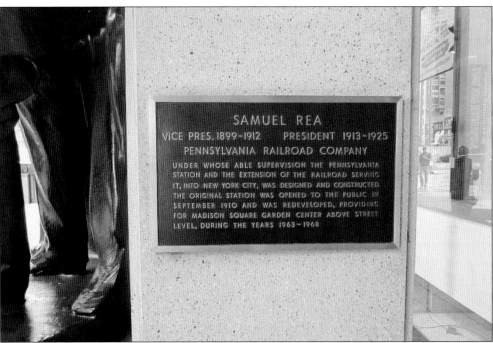

This bronze plaque is mounted on the pillar behind Rea's statue. This is certainly a nice tribute to Rea and his role in developing Penn Station, but it sadly included a bit more than what was needed. Stating that the station was "redeveloped" during the years 1963 to 1968 is a different way of saying that the once-glamorous building was torn down in a senseless act of disregard for a beautiful structure that was built to last hundreds of years.

Four

GRAND CENTRAL STATION EAGLES AT THE TERMINAL

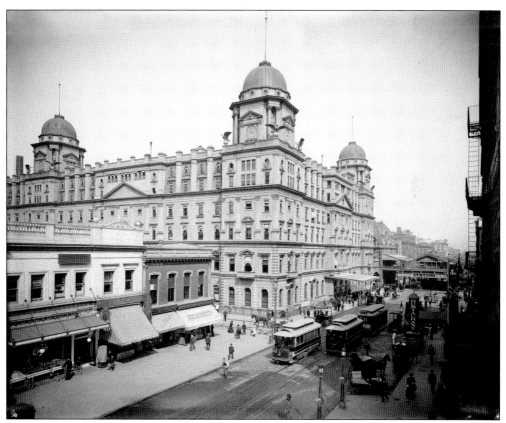

This c. 1900 photograph of Grand Central Station was taken from across Forty-Second Street, looking northeast. Trolleys and horse-drawn carriages are seen on Forty-Second Street with the Park Avenue spur of the Third Avenue elevated subway in the distant right. The 1871 building was renovated in 1898, with three floors as well as four domed towers above the roofline being added. Three of the towers are seen here, and seven of the cast-iron eagles are visible. Architect Bradford Lee Gilbert designed this renovation, but the sculptor who designed the eagles is unknown.

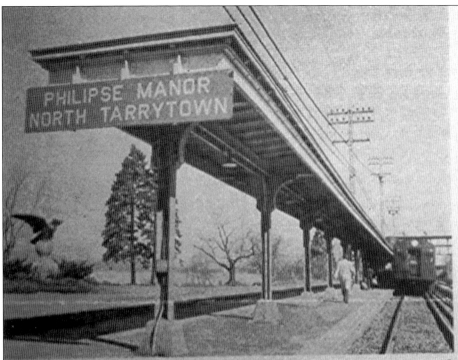

And then there was one! Today, at N.Y. Central's North Tarrytown, N.Y., station, stands only eagle left (as far as anyone knows). What happened to the others?

Where did the eagles go?

CONSIDER YOURSELF an oldtime New Yorker if you remember the original Grand Central Station on 42d St. Built in 1871 and enlarged in 1898, the station roof was adorned with eagles. But the birds have mysteriously flown the coop since the present station was completed in 1913—except for one spotted upstate by our alert photog.

NEW YORK SUNDAY NEWS · OCTOBER 31, 1965

The story of the Grand Central Station eagles was established by David McLane, a freelance writer and photographer who did extensive work for the *New York Daily News*, one of New York City's major newspapers. One of his noted features was weekly photographs of "New York's Changing Scene," wherein he contrasted the old and the new pertaining to the landscape and buildings of the city. In 1965, he photographed an eagle at the Philipse Manor–North Tarrytown Station of the New York Central Railroad. Learning that this eagle was from the former Grand Central Station building and seeing the photograph on the previous page, his curiosity got the better of him. He was interested in learning how many of the other eagles were still around, so in the October 31, 1965, edition of the paper, he showed a photograph of the Philipse Manor eagle and asked readers to provide information regarding the whereabouts of any remaining eagles.

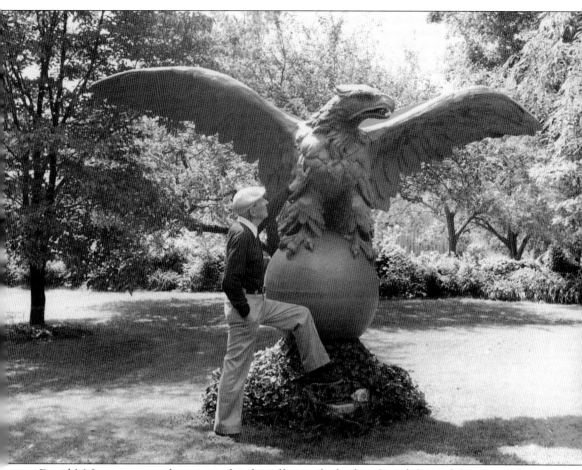

David McLane was not disappointed in his effort to find other Grand Central Station eagles. Through reader responses to his October 31, 1965, inquiry, he learned the location of nine other eagles. All 10 were within a 50-mile radius of New York City. The results of his quest were published in the January 2, 1966, edition of the *New York Daily News*. McLane became obsessed with the eagles and wanted to learn more about them. He theorized that there were 10 or 11 eagles at the corners of the towers, with none on the inner corners of the towers that overlooked the train shed since they would not have been visible to the public. He was not sure that he found all of the eagles, but his obsession led him to purchase one, which he placed in his yard, as seen in this 1966 photograph taken by his son Denis McLane. The eagle had a 14-foot wingspan, was 8 feet high, and weighed 1.5 tons.

One of the eagles that McLane found was in the backyard of a Bronxville, New York, home. The author, inspired by McLane's eagle search, visited the Bronxville home in 1993 and was allowed to photograph the eagle, as seen here. The owner had no interest in talking about the eagle. In 1995, Laurie Hawkes and Paul Grand Pre purchased the home, and when the author visited, they were most interested in talking about the eagle. They had heard that the eagle had to be from a building in New York City but were not sure which. When told it was at Grand Central Station and shown photographs of the eagles on the old building, they were quite pleased. They asked the author what his interest was in the eagle, and he told them that he would like to see it returned to Grand Central.

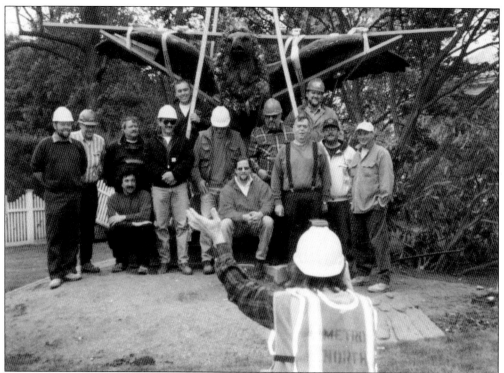

Laurie Hawkes contacted Metropolitan Transportation Authority (MTA) board chairman E. Virgil Conway and told him about the eagle on her property. Conway made a visit to see the eagle, and loved the idea of it coming back to Grand Central. Arrangements were made for the eagle to be donated to the railroad for placement at the terminal. On May 10, 1997, a Metro-North Railroad crew arrived at the Bronxville residence and took away the eagle. The above photograph shows the crew members having their photograph taken in front of the eagle by company photographer Frank English. Below is a photograph of the eagle being lifted by a crane for placement on the truck. The eagle was taken to the Architectural Iron Company in Milford, Pennsylvania, for restoration prior to being sent to Grand Central Terminal.

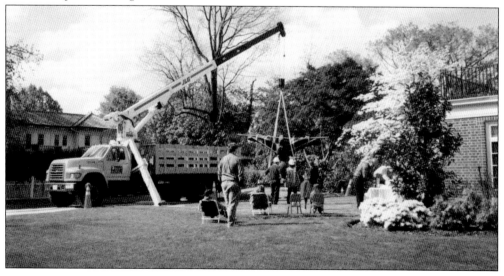

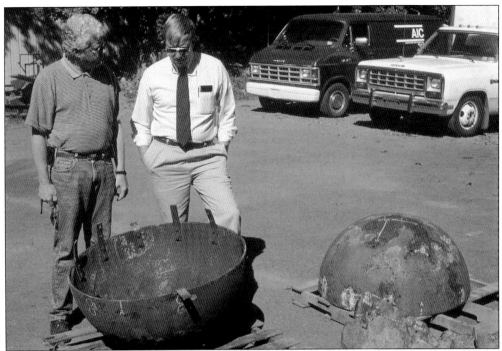

The cast-iron eagles were produced from pieces that were bolted together rather than welded. Once at the Architectural Iron Company, the eagle was completely disassembled, and the parts were sandblasted clean, coated with primer, reassembled, and then painted with a finishing coat of weather-resistant paint. While the eagle was apart, it was carefully examined for any markings that might have led to the identity of the sculptor or foundry, but nothing was found. Above, Metro-North Railroad chief architect Wayne Ehmann (left) and Architectural Iron Company president Don Quick examine the ball upon which the eagle rested. Below, the author is seen kneeling next to the eagle head, which was too heavy to lift. The photograph below was taken by Wayne Ehmann.

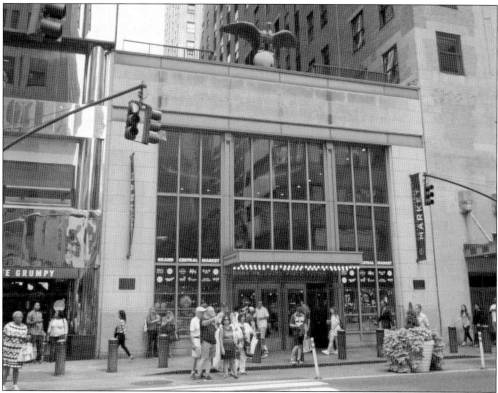

When Grand Central Terminal was being restored in the late 1990s, many wondered where the Bronxville eagle would go. At that time, the thought was that it could not be placed in front of the building due to the landmark status of Grand Central Terminal; however, many still did want the eagle to be placed outside and not inside the building. The saving grace was the new entrance that was to be placed at Lexington Avenue, which was not subject to the landmarks law. There was a large clock in the design drawings, which was scrapped in favor of the eagle. These photographs show the eagle as it appears today over the Lexington Avenue entrance to the terminal. The doors lead people through a food court on their way into the terminal.

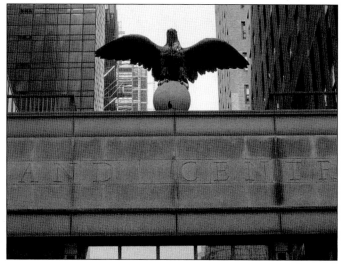

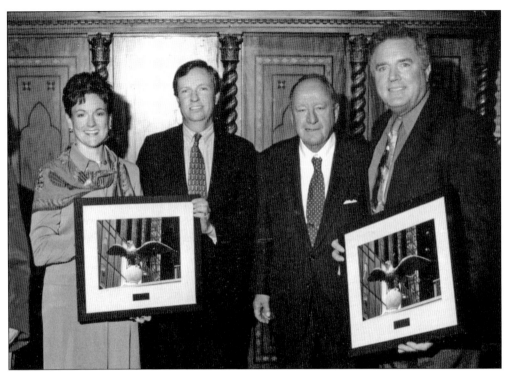

The Bronxville eagle was scheduled to be officially unveiled on October 18, 1999. Thanks to Laurie Hawkes, the author was invited. Prior to the unveiling, board chairman E. Vigil Conway presented framed photographs of the eagle over the Lexington Avenue entrance. At the presentation ceremony, seen above, the owners of the eagle, Laurie Hawkes and Paul Grand Pre, stand at Conway's right while the author stands to his left. Below is the framed photograph that Conway presented to the author; on the back he wrote, "David, you have been so responsible for all of the eagles but especially for the return of the Bronxville Eagle. Thanks!! E. Virgil Conway, Chairman MTA 10/18/99." These photographs were taken by MTA photographer Patrick Cashin.

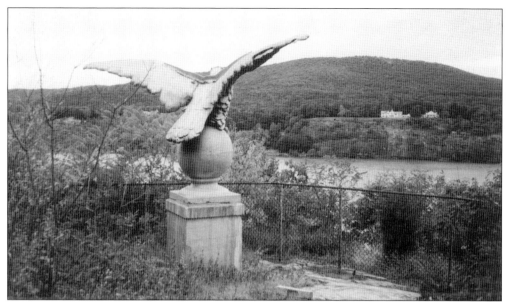

Another eagle that David McLane found in 1965 was the one at the Capuchin Seminary in Garrison, New York. This eagle was in a nearly inaccessible location, requiring a walk through a wooded area to get to it. Yet, the location was probably the most befitting of an eagle—high on a cliff with the Hudson River in front of it. The eagle looked as though it was ready to take flight across the majestic river.

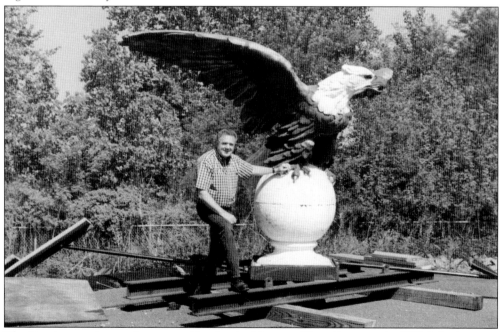

The Garrison eagle was also restored by the Architectural Iron Company in 2001. It had not yet been determined where the eagle would be placed at Grand Central Terminal, so it was decided to store the eagle in the southwest section of Metro-North's Harmon yard, only a short distance from the Hudson River. In this May 10, 2001, photograph, the author stands next to the eagle. This photograph was taken by a Metro-North Railroad supervisor.

This photograph shows the Garrison eagle at the corner of Forty-Second Street and Vanderbilt Avenue. The eagle does not belong here. It is redundant, and this is not the view that Jacqueline Kennedy Onassis enjoyed when she fought so hard to have Grand Central Terminal preserved. Needless to say, the MTA was able to get approval from the New York City Landmarks Commission for the placement of the eagle here for two reasons: it was not on the building and was only temporary, yet it is still there after 14 years.

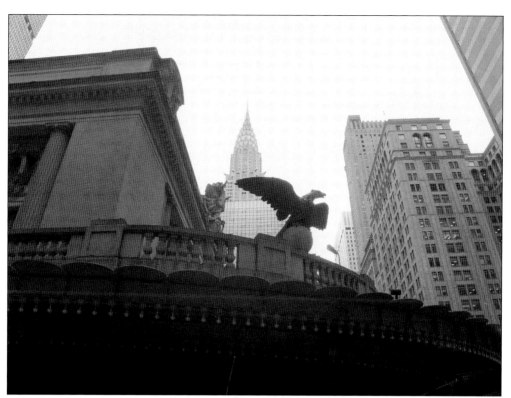

The Garrison eagle looms over the southwest entrance to the terminal, with the Chrysler Building in the background. Since the Chrysler Building opened on May 27, 1930, this was the first time that a Grand Central Station eagle was within sight of it. The eagle might look nice here, but it does detract from the historic appearance of Grand Central Terminal.

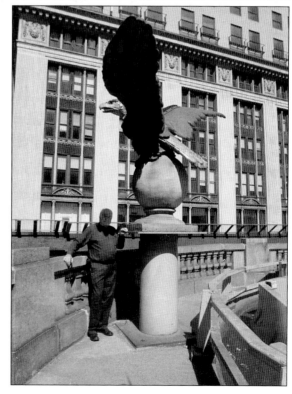

This photograph of the author standing next to the Garrison eagle was taken on April 22, 2015, during a videotaping of a television episode to appear on the Disney Channel. The author was interviewed for a program about Grand Central Terminal, which appeared on *Secrets of America's Favorite Places*, season 1, episode 6, which aired on August 7, 2016. This photograph was taken by an Indigo Films staff member.

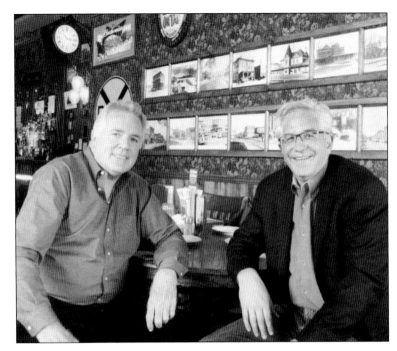

Another television program featuring the Grand Central Station eagles appeared on the History Channel. The author was interviewed by host Wes Cowan for *History Detectives*, season 5, episode 9, which aired on August 20, 1997. Here, the author and Cowan (right) were photographed during a break during the videotaping. This photograph was taken by Diane Morrison.

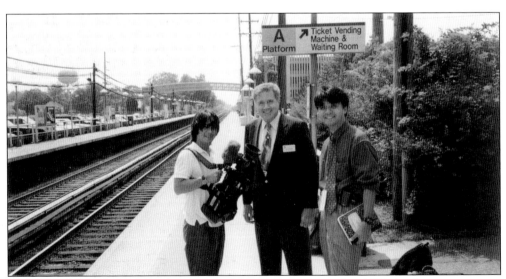

The story of the Grand Central Station eagles went international in 1997. A television program about the eagles appeared on NHK-TV in Japan. Seen here at Mineola Station on September 9, 1997, the author stands between two representatives of the Japanese television production team. This photograph was taken by an NHK-TV staff member.

Five

GRAND CENTRAL STATION EAGLES AT OTHER LOCATIONS

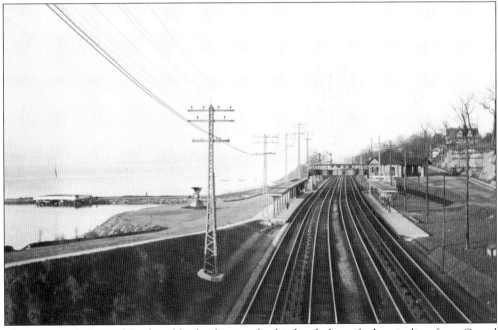

The New York Central Railroad had a four-track, third-rail-electrified main line from Grand Central Terminal to Harmon, as seen in this c. 1911 photograph of Philipse Manor Station. Note both station platforms and the pedestrian overpass in the distance. To the left, the eagle is perched on the banks of the Hudson River, facing the tracks. This is the eagle that caught David McLane's eye in 1965, as told on page 54. (Courtesy of Westchester County Historical Society.)

This c. 1911 photograph shows the Philipse Manor Station at right and the Grand Central Station eagle at left. The station building was erected on a bluff that was created when a cut was excavated by the railroad to widen the right-of-way. Developer William Bell paid for the station building and presented it to the railroad. That is probably why the eagle was given by the railroad to be placed at this location. The canopies had not yet been constructed over the station platforms. (Courtesy of Westchester County Historical Society.)

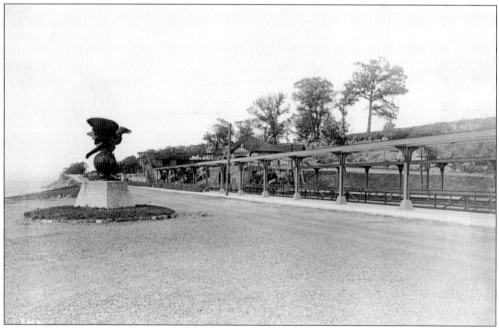

The support structures for the station platform canopies had been erected, but the canopy roofs were not yet in place when this c. 1911 photograph was taken. The bare ground around the eagle suggests that it had been recently put in place. (Courtesy of Westchester County Historical Society.)

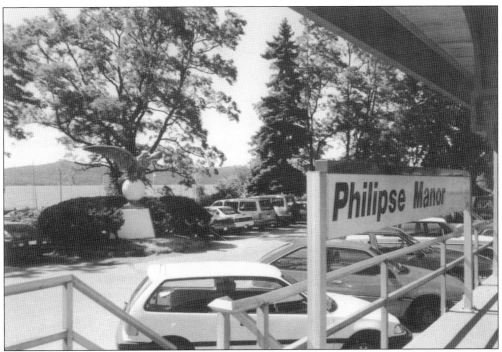

In this recent view from the station platform, the Philipse Manor Station destination sign commands the foreground, while the eagle can be seen at left with the Hudson River to the far left. When David McLane photographed the eagle in 1965, the station was named Philipse Manor–North Tarrytown. In 1996, the village name was changed from North Tarrytown to Sleepy Hollow. Today, the Metro-North station's name is Philipse Manor.

This north-facing view shows the profile of the Philipse Manor eagle with the station building in the background. This is the only Grand Central Station eagle that is painted gold. It rests upon a round, white base. Looking inside its mouth, one can see that the tongue is extended and pointing upward. According to eagle experts, this was to portray an eagle screeching. The station building has been leased out by the railroad, and is now the home of the Hudson River Writers' Center.

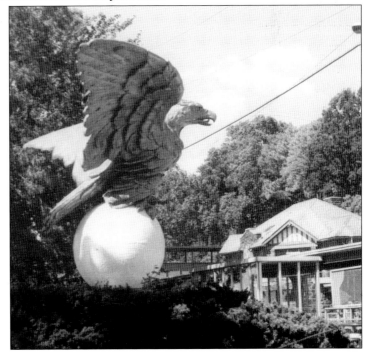

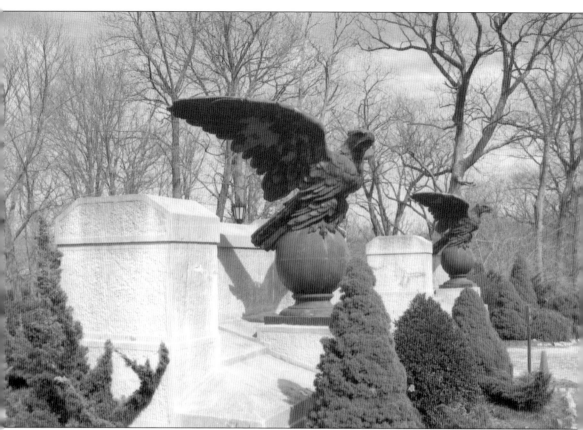

Prior to the demolition of the Grand Central Station building in 1910, the cast-iron eagles were dispersed to various locations in New York State, mostly to estates of Vanderbilt family friends. Six of the eagles went in pairs; one pair to a Mount Vernon estate, another to a Cold Spring estate, and a third pair to the estate of William K. Vanderbilt Jr. in Centerport. His estate was known as Eagle's Nest and is now the not-for-profit Vanderbilt Museum operated by Suffolk County. This photograph shows the eagles at the entrance to the museum.

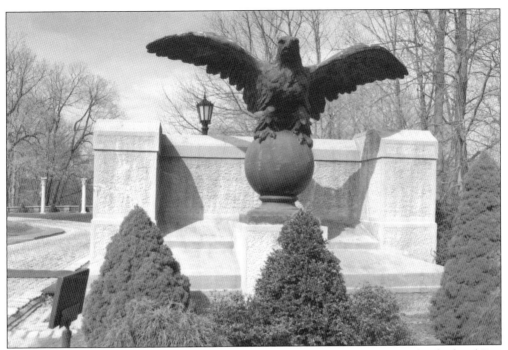

The Vanderbilt Museum eagles were painted with a black preservative coating by the local Boy Scouts in the 1990s. These eagles, along with one of the eagles in Cold Spring, New York, are the only Grand Central Station eagles painted black. All of them were of the same design, but with some facing straight and others facing to one side or the other. The direction of the heads can be clearly seen in these two photographs. The cement pedestals and backdrops are quite substantial and impressive. Visitors do not have to pay a fee to see these eagles, and photographs are permitted.

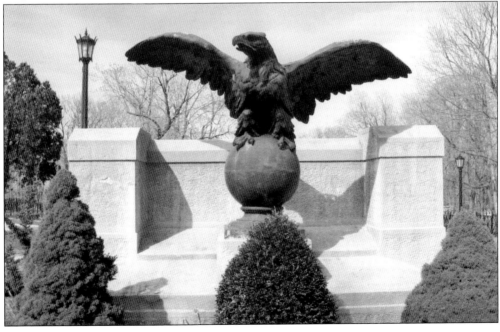

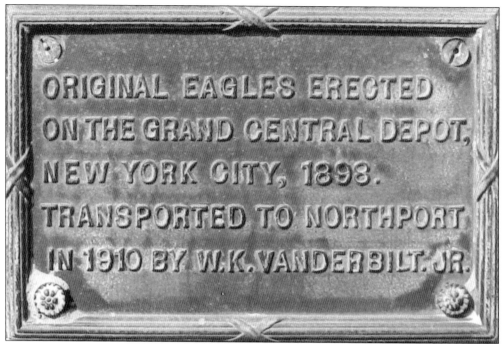

ORIGINAL EAGLES ERECTED
ON THE GRAND CENTRAL DEPOT,
NEW YORK CITY, 1898.
TRANSPORTED TO NORTHPORT
IN 1910 BY W.K. VANDERBILT. JR.

This is one of the two identical plaques mounted on the cement pedestal below each eagle at the Vanderbilt Museum. Unfortunately, the name of the sculptor who designed these fine pieces of art does not appear.

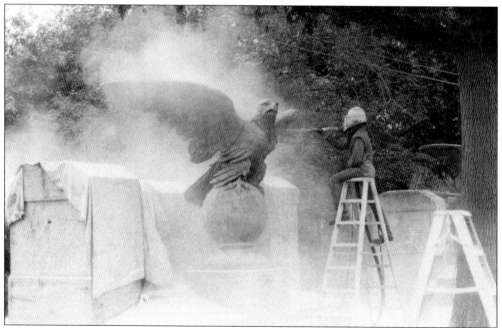

This undated photograph was in the Vanderbilt Museum archives. It appears the eagle is being sand-blasted. Tarps cover the cement surroundings, and the person doing the spraying is wearing a protective face mask. This might have been the cleaning prior to the Boy Scouts painting the eagles in the 1990s.

In 1910, two of the eagles went to an estate in Mount Vernon. In later years, that estate was subdivided into smaller parcels of land, and homes were built on the sites. The eagle that was once at 102 Villa Street was photographed in 1965 by David McLane, but it is gone. The whereabouts of that eagle are unknown, but the pedestal upon which it rested was still there when this photograph was taken in 1991.

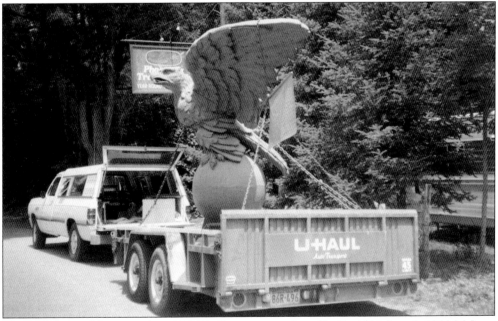

The other Mount Vernon eagle at 110 Villa Street was purchased by David McLane in 1966. McLane purchased the eagle for $100. Today, these eagles are appraised at over $100,000. A photograph of McLane standing next to the eagle in his backyard can be seen on page 55. In 1985, McLane donated his eagle to the Town of Shandaken, New York. The eagle is seen here on July 8, 1985, being transported to its new home in Shandaken. (Courtesy of Denis McLane.)

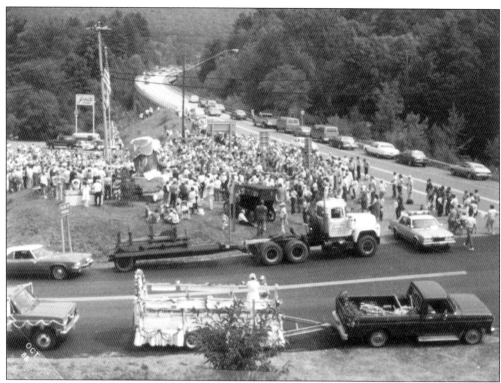

Once at Shandaken, the eagle was brought to the Phoenicia Forge, where it was restored by metal worker and sculptor Dakin Morehouse. It cost $10,000 to move, repair, and mount the eagle on a piece of town land at the crossroads of State Routes 28 and 214. The money was successfully raised, mostly through small donations from local residents. The eagle was dedicated and unveiled at a ceremony on August 23, 1986, as seen in these photographs. Sadly, David McLane passed away shortly before this and missed seeing his eagle in its new home. CBS-TV newscaster Roland Smith presided over this ceremony, held 20 years after McLane purchased the eagle. (Both, courtesy of Denis McLane.)

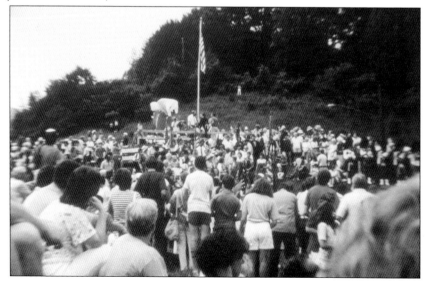

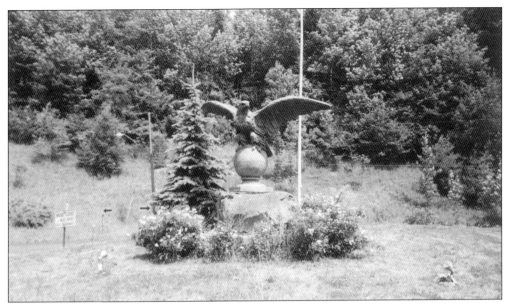

In this 1995 photograph, the Shandaken eagle looks as though it is ready to take flight. Dakin Morehouse performed the 1985 restoration work. He strengthened the eagle pieces with stainless steel bolts and sprayed the eagle with a layer of zinc metal coating. He then applied a decorative outer surface of an aluminum-bronze coating. The eagle would have to be given periodic maintenance to prevent deterioration. Morehouse has been lovingly taking care of the eagle for over the past three decades.

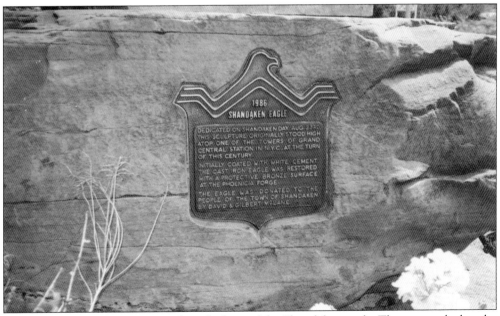

This is the plaque that is mounted on the base of the Shandaken eagle. The text reads that the eagle was "initially coated with white cement." There is no indication that any of the other eagles had a cement coating. This coat was most likely applied while the eagle was in Mount Vernon or when owned by David McLane. Buried by the eagle's base is a time capsule that is to be opened in 2076 for the nation's tricentennial.

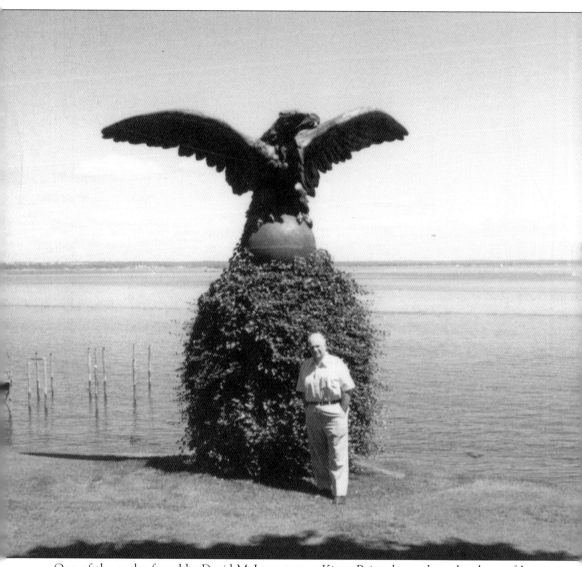

One of the eagles found by David McLane was at Kings Point, located on the shore of Long Island Sound. In 1910, that eagle was placed on the estate of Hannibal Choate Ford, who was a coinventor of sonar, along with Elmer Sperry. In 1905, Ford got a patent for railroad speed control technology, and worked with Sperry on developing rail flaw detection equipment. As with many of the large estates on the north shore of Long Island, the Ford estate was subdivided through the years. Eventually, the land upon which the eagle rested was purchased by Edwin and Nancy Marks, and they built a house on the property. The location is ideal for this eagle, as can be seen in this 1996 photograph. Note the vines covering the pedestal. Above, owner Edwin Marks stands in front of his beloved eagle.

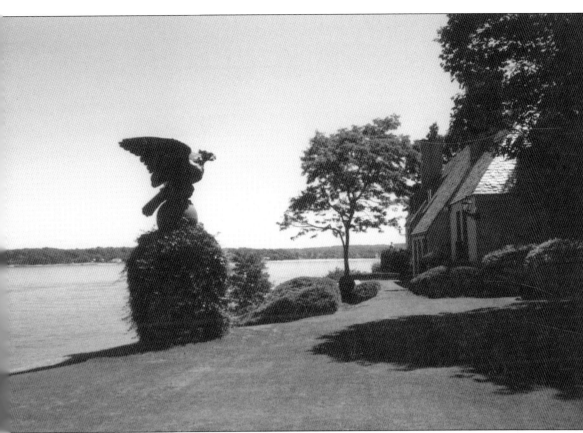

The beauty of the setting for the Kings Point eagle can be easily seen in this 1996 photograph. This is a view looking east with the Marks house at right. A photograph of the eagle is in the archives of the Great Neck Library, photograph No. 441, file No. 7825A1, identified as "Eagle – Mechanical." The document further states, "Eagle is movable, said to respond to barometric pressure," which is not true. In 1998, when Edwin Marks had the eagle restored, there was absolutely no indication that the eagle was ever mechanical.

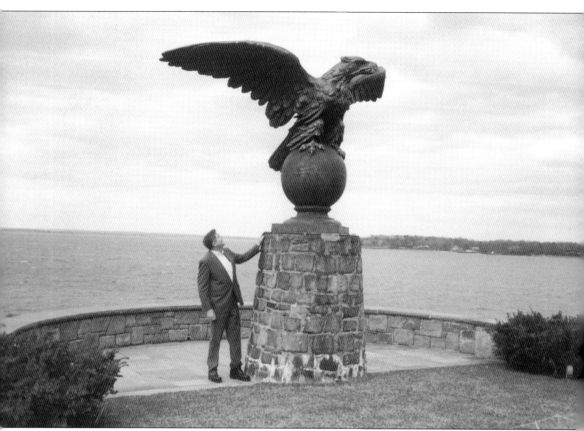

On March 30, 1997, the *New York Daily News* ran a feature article concerning the author's interest in the Grand Central Station eagles. Under the heading, "Eagle-Eyed LIRR Man Has Aerie Obsession," staff writer Robert Gearty gave appropriate recognition to David McLane, who first documented the eagles. Gearty wrote, "McLane's photographs of those eagles appeared in the old *Sunday News* magazine on January 2, 1966, but after that, they seemed to disappear again. Until Morrison came along." *Daily News* photographer Willie Anderson was sent to Kings Point to photograph the eagle on the Marks property on March 30, 1997. This is the photograph that Anderson took of the author with the eagle on that day. (Courtesy of *New York Daily News.*)

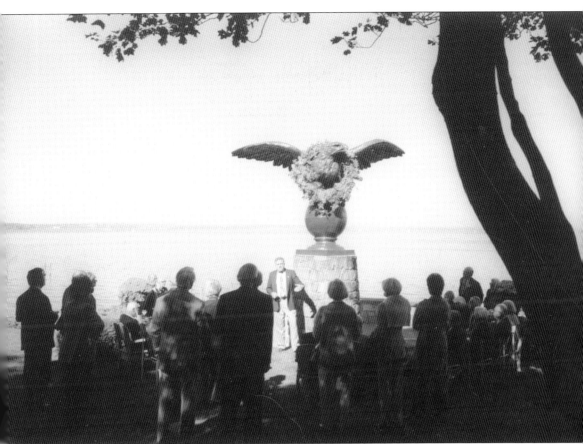

After Edwin Marks had his eagle restored, he and his wife, Nancy, hosted an "eagle party" on October 25, 1998. They invited family and friends and graciously invited the author. A large wreath was placed over the eagle, which looked wonderful with its fresh coat of bronze paint. The vines had been removed from the pedestal. The photograph shows the author giving a talk about the history of the eagle to the guests. Marks presented each guest with a copy of the booklet *The Cast Iron Eagles of Grand Central Station*. This photograph was taken by Edwin Marks.

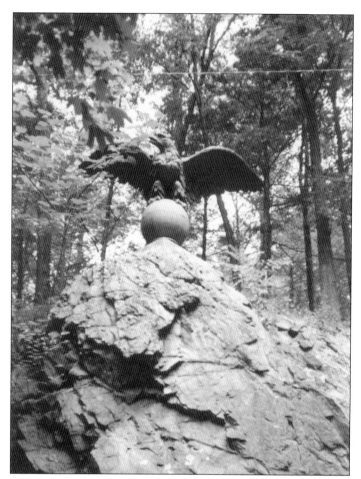

David McLane photographed two eagles at St. Basil's Academy in Cold Spring, New York, in 1965. Rev. Demetrius Frangos, director, graciously allowed McLane to view and photograph the eagles. These eagles appear to have no relation to each other. One is on a cliff overlooking the main driveway, and although painted black, it is easily visible, as seen at left. Below, the other eagle is set back from the road and painted bronze. Both are well cared for.

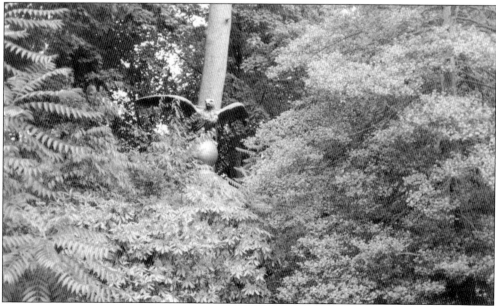

In 1966, when David McLane photographed the 10 Grand Central Station eagles, he thought that there could very well have been an 11th eagle, but he was unable to confirm that. As mentioned on page 71, one of the Mount Vernon eagles that McLane photographed has since disappeared. Even after extensive research, the author was unable to find any information about the missing eagle. Then, one day in March 2003, the author received a phone call from Don Quick, with information that a Grand Central Station eagle was at the Space Farms Zoo and Museum in Sussex, New Jersey. This was truly an exciting find. The photograph above was taken from Country Road 519. Below is a photograph of Lori Day Space, owner of the zoo, standing in front of the eagle.

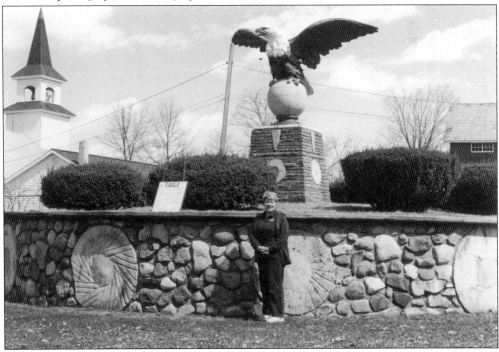

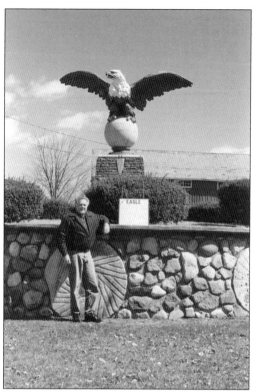

Space Farms and Zoo Museum owner Ralph Space purchased the eagle from a junkyard in Newburgh, New York, in the early 1970s. Located near the entrance to his facility, the eagle has a substantial pedestal and base made of fieldstones and river rocks with decorative millstones. Here, the author is standing next to the information plaque. This photograph was taken by Lori Day Space.

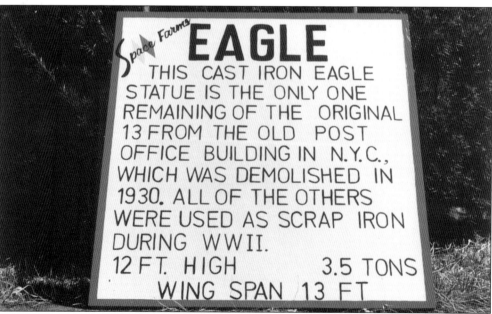

Space Farms **EAGLE**
THIS CAST IRON EAGLE STATUE IS THE ONLY ONE REMAINING OF THE ORIGINAL 13 FROM THE OLD POST OFFICE BUILDING IN N.Y.C., WHICH WAS DEMOLISHED IN 1930. ALL OF THE OTHERS WERE USED AS SCRAP IRON DURING WWII.
12 FT. HIGH 3.5 TONS
WING SPAN 13 FT

Ralph Space mistakenly believed that the eagle was once on an old post office building in New York City. He produced a sign with the erroneous information on it, as seen here. There is no doubt that this is a Grand Central Station eagle, as was confirmed by Don Quick, who took apart and restored two of these same types of eagles. The question is whether this was the missing Mount Vernon eagle or the 11th eagle that David McLane suspected existed.

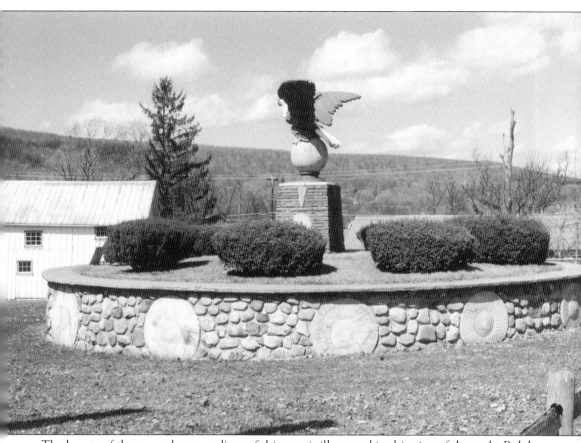

The beauty of the natural surroundings of this area is illustrated in this view of the eagle. Ralph Space never told anyone how much he paid for the eagle, and the family has been unable to find any paperwork pertaining to the purchase. The family is very happy that they have such a historic artifact on their property. Don Quick offered to purchase the eagle, but the family told him that the eagle was staying where it is. As stated on the Space Farms and Zoo Museum website, "The last eagle to be found landed, appropriately, at a zoo!"

In 1992, the American Booksellers Association (ABA) purchased a mansion in Tarrytown, New York, known as the Moller House. The association produced a booklet promoting the historical significance and beauty of its new headquarters. The cover of the booklet is seen here. In the centerfold, there is a photograph of Grand Central Station and text stating that there once was an eagle from the station on the property.

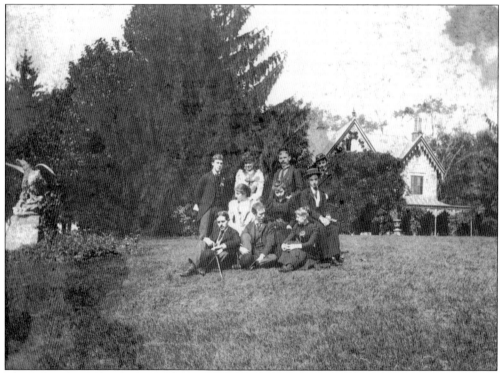

The author decided to find out if there was any truth to the ABA's eagle story and was able to track down the great-grandson of the original owner of the mansion. G.B. Daniell Jr. sent the author this photograph, which was taken in 1891—seven years prior to the eagles being placed on Grand Central Station. The eagle is clearly not a Grand Central Station eagle. It is not mounted on a ball, and the head is raised far too high. History has been corrected thanks to this photograph. (Courtesy of G.B. Daniell Jr.)

Six

PENN STATION EAGLES IN NEW YORK STATE

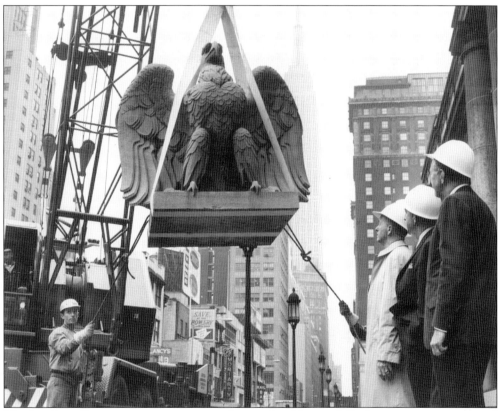

The four Penn Station statuary groups were discussed in Chapter 2. Each statuary group consisted of a clock in the center, figures of Day and Night on each side of the clock, and eagles abutting the figures. These eight eagles were trimmed on the sides adjacent to the figures, and were slightly smaller than the other 14 eagles on the building. This chapter will discuss the six larger, free-standing eagles in New York State. Chapter 7 will discuss the eight free-standing eagles in other states. This October 28, 1963, photograph, taken on the official start day of the Penn Station demolition, shows one of the eagles being lowered from the Thirty-Third Street side of the station. The three officials at right wearing hardhats are, from left to right, Long Island Rail Road president Thomas Goodfellow, PRR vice president J. Benton Jones, and Madison Square Garden president Irving M. Felt. After the demolition, a new Madison Square Garden replaced Penn Station. (Courtesy of Joan Amundsen.)

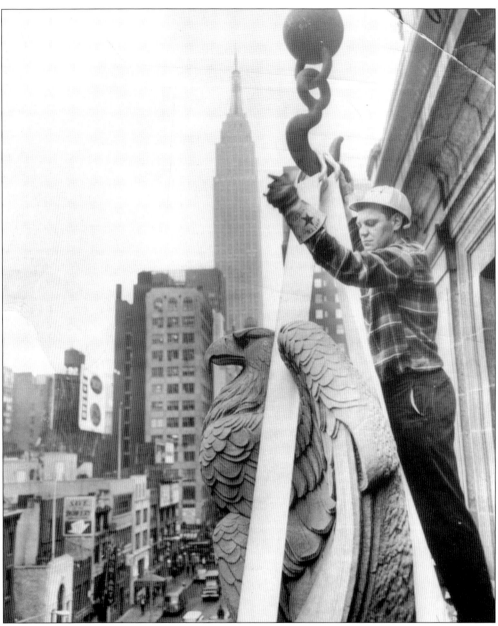

One of the eagles that was mounted on the Thirty-Third Street side is seen here strapped and ready to be lowered to a flatbed truck on the street. It appears as though the workman is giving the signal for the crane operator to start the lift-and-lower operation. The Empire State Building is in the distance, nicely framed over the eagle's head. (Courtesy of John Turkeli.)

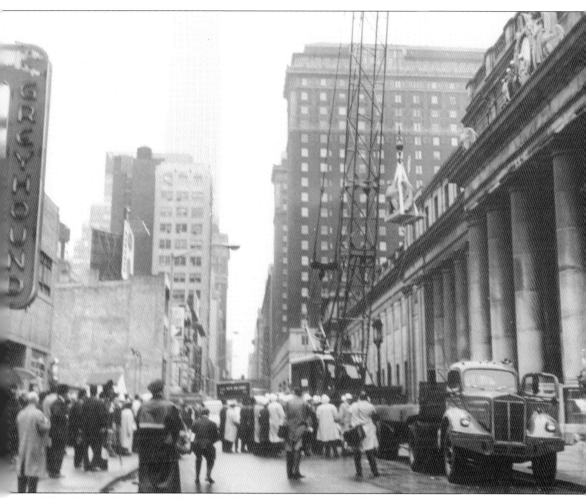

This distant shot along Thirty-Third Street shows the crowd that had gathered to watch the eagles being lowered. The building looked quite filthy from years of city smoke and PRR's extreme neglect. At left is the sign for the Greyhound bus terminal, in the distance is the Empire State Building, and the Pennsylvania Hotel looms beyond Penn Station.

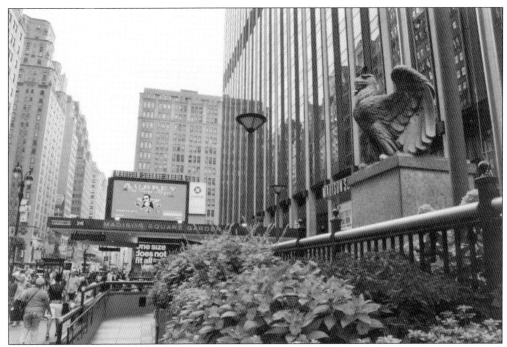

Two of the larger eagles were kept at the Penn Station location for permanent placement after Madison Square Garden opened on February 11, 1968. Both eagles are at the Seventh Avenue front entrance to the building, with the huge Madison Square Garden marquee in the middle. These August 27, 2018, photographs looking south show the eagle on the north side. It is mounted on a high pedestal. Stairs under the marquee lead down to the Amtrak and Long Island Rail Road trains.

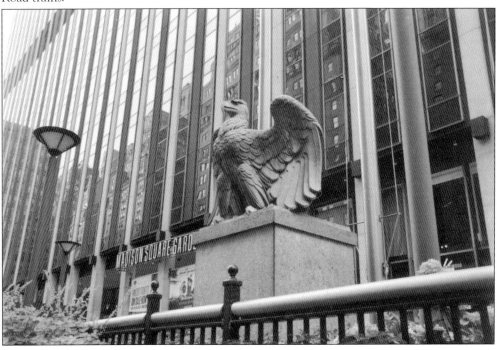

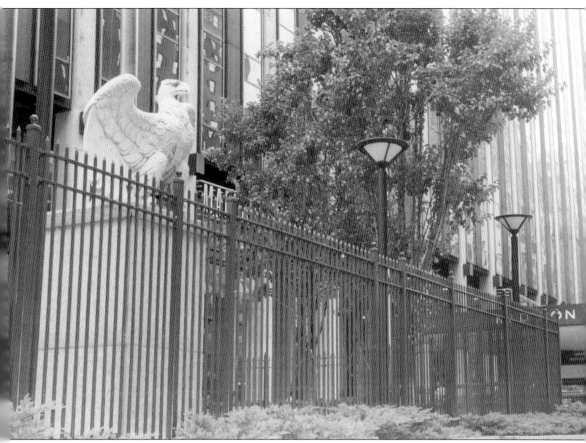

The eagle on the south side is mounted on a similar pedestal, but unfortunately, there is a high fence in front of it, making it more difficult to see and photograph. This photograph, looking north, was taken on August 13, 1997, with the Madison Square Garden marquee to the right.

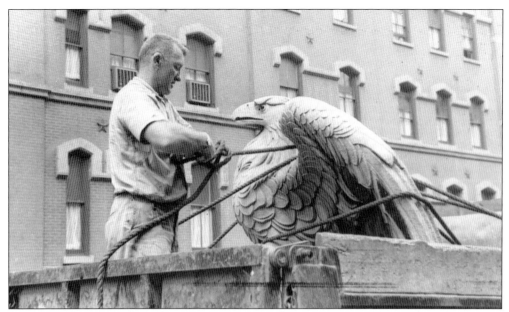

One of the eagles was donated to Cooper Union College in Lower Manhattan because sculptor Adolph Weinman graduated from there in 1891. The eagle was transported to Green Camp, a rural educational and recreational center run by the college, located on a 1,000-acre tract of woodland in Ringwood, New Jersey. Above, the eagle is being secured on a truck for transportation to Green Camp. Below, the eagle is being unloaded at the camp. These photographs and the photograph at the top of the facing page were obtained by Joan Amundsen for her four-page feature article "Where are the Penn Station Eagles?" in the May 1972 issue of *Railroad* magazine. (Both, courtesy of Joan Amundsen.)

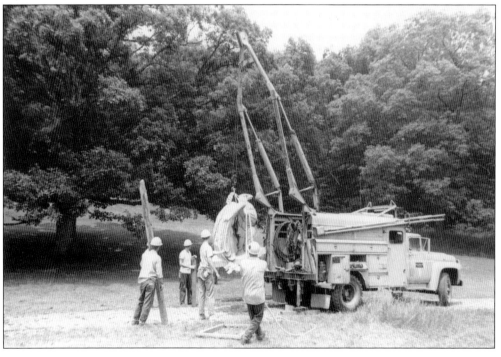

If this undated photograph is any indication, the eagle must have been a big hit with the students at Green Camp. But it was not there for long. In 1973, Cooper Union sold the property and moved the eagle back to the city and placed it in the courtyard of the engineering building. (Courtesy of Joan Amundsen.)

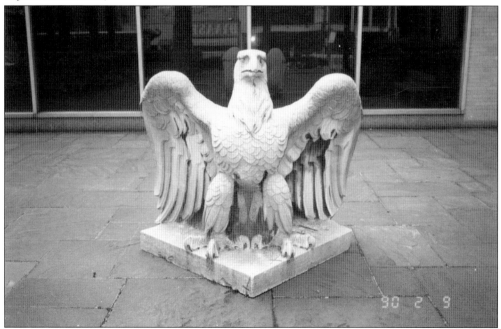

The eagle is seen in the courtyard on February 9, 1990. It is one of the only two on a diamond-shaped base. The other is at the National Zoo in Washington, DC. These eagles were mounted on the Thirty-First Street side of Penn Station, as can be seen in the photographs on page 30.

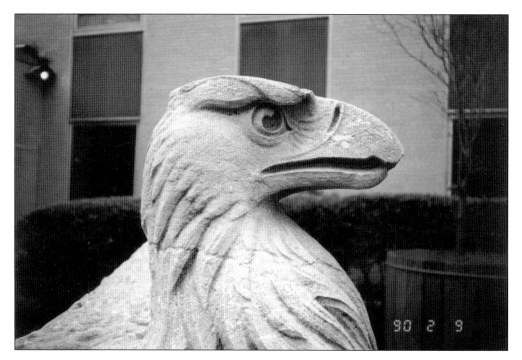

These photographs of the eagle in the Cooper Union courtyard illustrate two points about the Penn Station eagles. First, as can be seen above, the beak was the most delicate part of these sculptures and only survived on a few of the birds. Second, the backs, as seen below, were not sculpted but rather left in rough stone. This is because these eagles were only meant to be seen from the front.

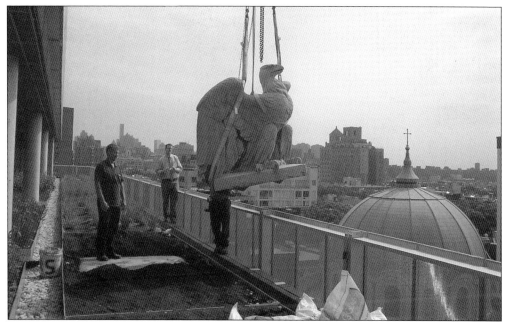

Cooper Union erected a new building at 41 Cooper Square that had a setback at the eighth floor, creating a terrace, which became known as the Green Roof. The engineering building was being sold, and the eagle had to be moved. In the summer of 2009, the eagle was placed on the Green Roof, facing inward toward the windows of a cafeteria. This photograph shows the eagle being lowered by a crane and placed into position. (Courtesy of Cooper Union.)

The eagle is seen at the far end of the Green Roof. Unfortunately, it is not in a position where it can be seen by the general public. It cannot be seen from the street, and anyone wishing to view it through the cafeteria windows would have to have a pass to get into the building. Fortunately, though, it is being nicely preserved. (Courtesy of Cooper Union.)

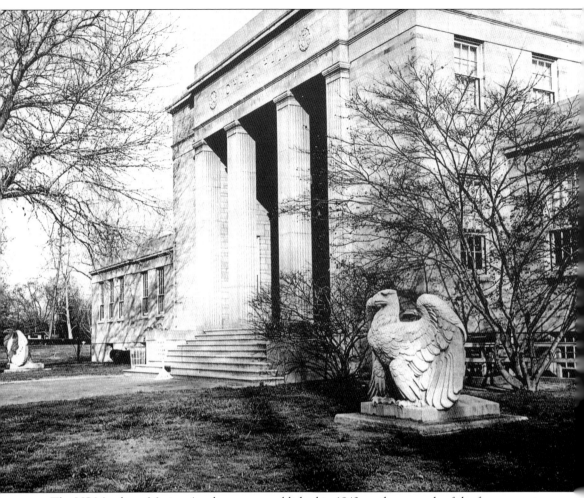

The US Merchant Marine Academy was established in 1943 on the grounds of the former estate of Walter Chrysler at Kings Point on the north shore of Long Island. In 1963, the academy's superintendent, Vice Adm. Gordon McClintock, thought that a few of the Penn Station eagles would look wonderful at the facility. He made his request to the PRR, and the company obliged and shipped the eagles free of charge to the academy. This photograph shows the eagles shortly after their placement there.

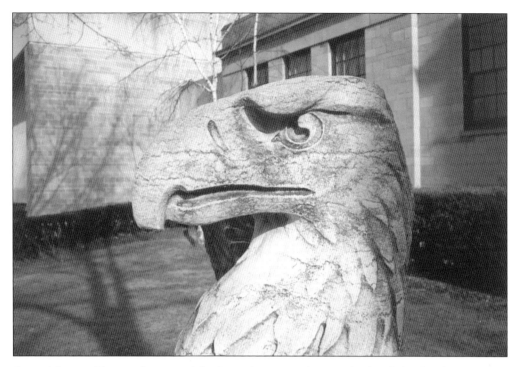

One of the troublesome features of the Penn Station eagles was the fragile beak. These January 1990 photographs of the Merchant Marine Academy eagles illustrate this point. The eagle pictured above is missing the point of its beak. Below, a poor restoration job was done on the other eagle's beak. A professional beak restoration can cost thousands of dollars.

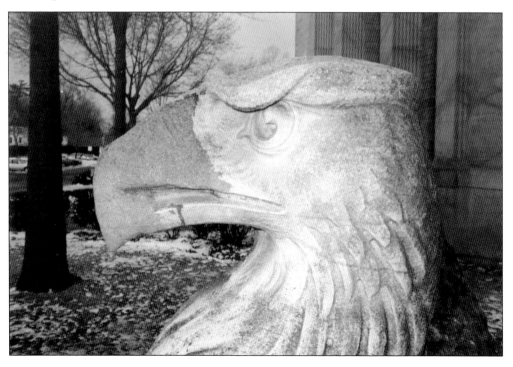

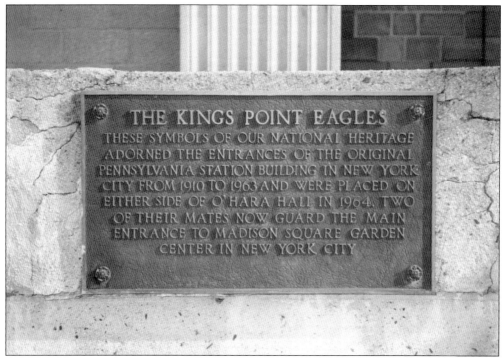

These are the plaques that are displayed close to each of the Merchant Marine Academy eagles. The above plaque gives mention to the two eagles that "guard the entrance to Madison Square Garden Center in New York City." The plaque below gives appropriate recognition to sculptor Adolph Alexander Weinman but erroneously states that "the granite is believed to have come from Milford, Massachusetts." The eagles were carved from marble, not granite.

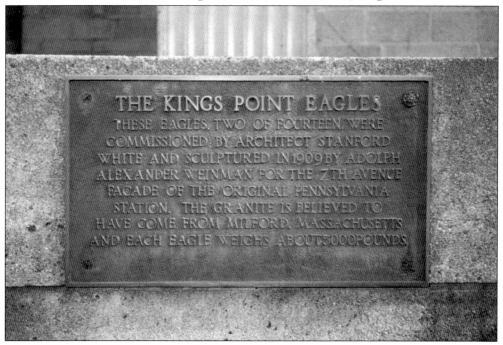

Through the efforts of Hicksville High School Latin teacher Samuel A. Goldberg, Hicksville was fortunate to receive one of the large stone eagles available when Penn Station was demolished. Goldberg was able to convince the PRR that it would be fitting for his Latin class to be able to obtain a symbol of ancient Rome—an eagle. The eagle was placed on a high pedestal in the station parking plaza and dedicated on May 15, 1965. At the dedication ceremony, high school students were dressed in white Roman togas, and Goldberg spoke many words in Latin. These photographs show the eagle being unveiled.

Samuel A. Goldberg was the moving spirit (*spiritus movens* in Latin) for getting the eagle to Hicksville. He taught Latin for 38 years. In 1965, his student Mark Horowitz said of Goldberg, "You are very fortunate in life if you have one teacher that truly inspires you. Mr. Goldberg was that kind of teacher. He was always trying to get us involved. He made Latin a living language."

This is the plaque that has been mounted on the eagle pedestal since it was dedicated on May 15, 1965. Fittingly, the words were written in English and Latin: "Heed the past in planning for the future" could certainly apply to New York City's two great train stations. The fact that the past destruction of Penn Station was heeded led to the preservation of Grand Central Terminal.

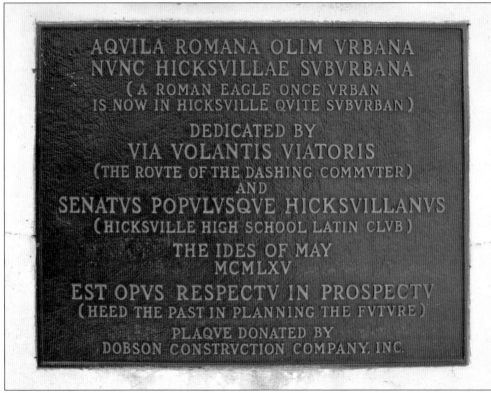

AQVILA ROMANA OLIM VRBANA
NVNC HICKSVILLAE SVBVRBANA
(A ROMAN EAGLE ONCE VRBAN
IS NOW IN HICKSVILLE QVITE SVBVRBAN)

DEDICATED BY
VIA VOLANTIS VIATORIS
(THE ROVTE OF THE DASHING COMMVTER)
AND
SENATVS POPVLVSQVE HICKSVILLANVS
(HICKSVILLE HIGH SCHOOL LATIN CLVB)

THE IDES OF MAY
MCMLXV

EST OPVS RESPECTV IN PROSPECTV
(HEED THE PAST IN PLANNING THE FVTVRE)

PLAQVE DONATED BY
DOBSON CONSTRVCTION COMPANY, INC.

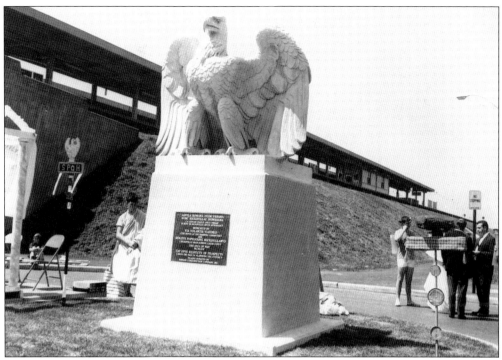

In another May 15, 1965, photograph, taken on the dedication day, looking west, the Hicksville Station platform can be seen south of the eagle. The eagle rests in the place that was once the location of the main line railroad tracks. After the elevated station opened on September 12, 1964, the ground-level tracks on the north side were torn up, and parking lots were installed.

On May 15, 1990, the Long Island Rail Road Historical Society (now defunct) and Hicksville High School held a 25th anniversary ceremony of the Hicksville eagle dedication. American flag bunting was wrapped around the base of the eagle, and the Town of Oyster Bay bandstand was set up behind the eagle, as seen at left. Standing in front of the eagle are, from left to right, Long Island Rail Road president Charles W. Hoppe, Samuel Goldberg's grandson Rafael Ruthchild, widow Ruth, and daughter Dr. Rochelle Ruthchild.

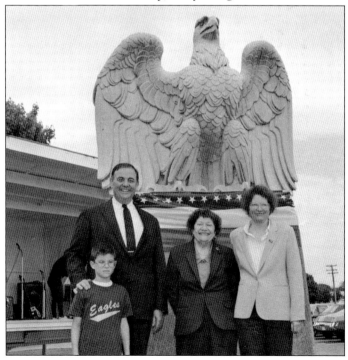

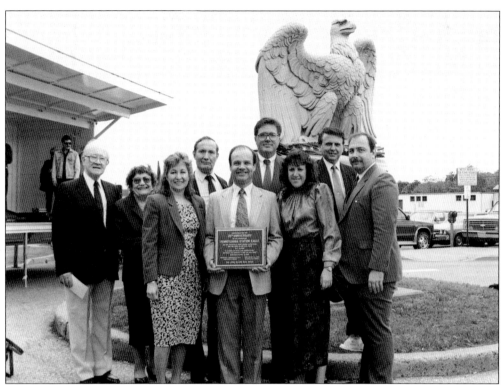

Above, members of the Long Island Rail Road Historical Society pose in front of the Hicksville eagle during the 25th anniversary ceremony. John Hehman holds the plaque, the author is behind his left shoulder, and Tom Tomaskovic is at far right. Tomaskovic and the author were the catalysts for getting the Penn Station bas relief mural installed on the Long Island Rail Road concourse at Penn Station (see page 38). Below is an image of the 25th anniversary plaque that is now mounted inside the train station waiting room.

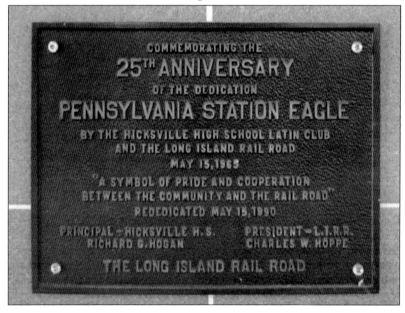

Effective April 16, 1990 ★

Port Jefferson Branch

An emblem was designed for the 25th anniversary of the Hicksville eagle by LIRR signal circuit designer and artist John Hehman. Seen here, the emblem was placed on the Port Jefferson branch timetables on April 16, 1990. A commemorative paperweight was also produced for the anniversary, which fetch a nice price whenever they appear on eBay.

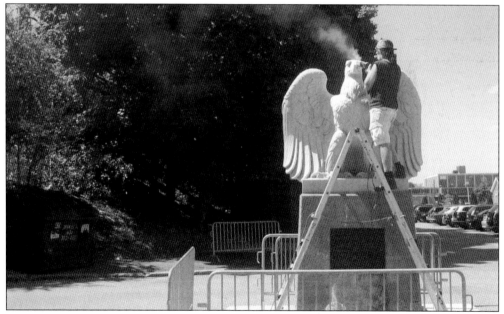

Through the years, weather took a toll on the Hicksville eagle, especially the beak, which disappeared almost entirely. In 2010, professional restoration work was performed on the eagle. The Hicksville Historical Society had raised the funds for the work, which was performed by Tatti Art Conservation of New York City. Here, one of the restoration workers is using a grinder to smooth out the new beak. This was a $7,000 nose job!

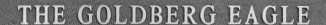

THE GOLDBERG EAGLE

HICKSVILLE HIGH SCHOOL TEACHER SAMUEL A. GOLDBERG
WAS THE "SPIRITUS MOVENS" BEHIND THE 1965
ACQUISITION OF THIS PENN STATION EAGLE.

OFFICIALLY DESIGNATED - OCTOBER 28, 2010

NASSAU COUNTY EXECUTIVE	EDWARD MANGANO
SUPERVISOR-TOWN OF OYSTER BAY	JOHN VENDITTO
HICKSVILLE HISTORICAL SOCIETY PRESIDENT	ROBERT KOENIG
EAGLE RESTORATION COMMITTEE	RICHARD ALTHAUS
	JOEL BERSE
	DAVID MORRISON
	JAMES PAVONE

On October 28, 2010, another ceremony was held at the Hicksville eagle upon the completion of the restoration work. At this event, the Hicksville eagle was officially named "the Goldberg Eagle." This plaque is now mounted on the eagle's pedestal above the 1965 plaque. It is a fitting tribute to the person who got the eagle to Hicksville.

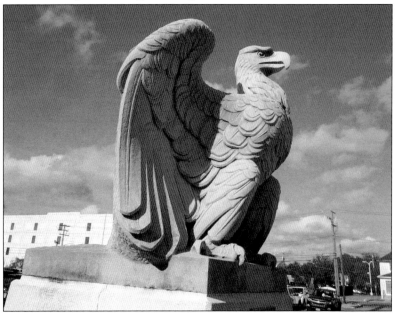

Here is the Goldberg eagle as it appears today. It faces east, which is the same direction that the eagles on the Seventh Avenue facade of Penn Station used to face. The morning sun shines directly on this beautiful sculpture as hundreds of commuters rush by on their way to the train.

Seven

PENN STATION EAGLES IN OTHER STATES

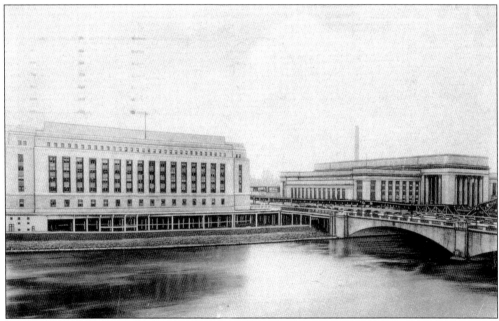

Four of the large Penn Station eagles were placed on the four corners of the Market Street Bridge, which crosses over the Schuylkill River in Philadelphia. It seemed like a fitting location, being in clear view of the PRR 30th Street Station, which is on the west bank of the river. This 1937 postcard shows the Market Street Post Office on the left and 30th Street Station in the right background.

This aerial photograph facing west shows 30th Street Station as the main subject. The Southeastern Pennsylvania Transportation Authority tracks go across the Schuylkill River at right, the John F. Kennedy Boulevard Bridge leads up to the center of the station building, and the Market Street Bridge can be seen at far left. One of the eagles is just barely visible.

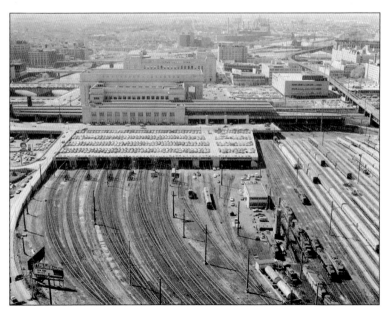

This aerial photograph facing south shows the tracks of Amtrak and New Jersey Transit leading into the lower level of 30th Street Station at left. To the right is the Amtrak passenger car storage yard. The Schuylkill River can be seen at upper left, and the double-span Market Street Bridge is the first bridge in view.

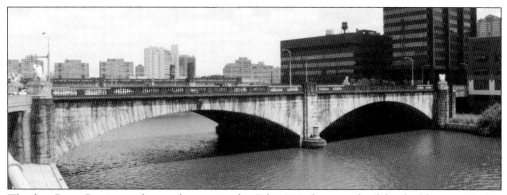

The four Penn Station eagles can be seen in this July 1990 photograph of the double-span Market Street Bridge looking northeast. Two of the eagles on the station side of the bridge can be seen at far left, and the other two can be seen at the distant right. Because of the length of the bridge, which is 1,300 feet long or slightly over four football fields, it is difficult to get all four eagles into a photograph.

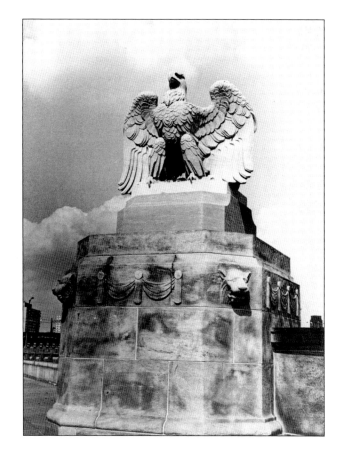

Each eagle rests upon a substantial cement decorative base. There are lions' heads at each corner of the square bases, which somewhat distract from the beauty of the eagles. The bases have had graffiti applied, but fortunately, the eagles have remained undisturbed.

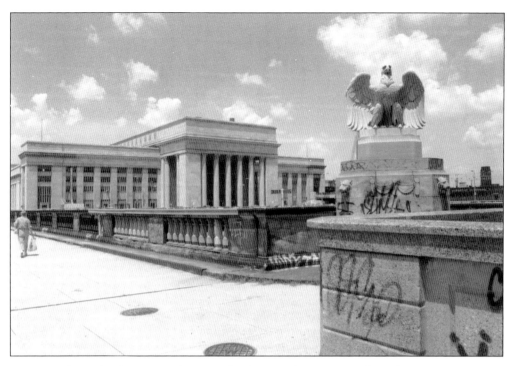

These are the eagles that are on the east side of the Market Street Bridge. Above is a photograph of the north eagle with 30th Street Station in the background. Although the station has six huge Corinthian columns at the main entrance, it is devoid of any statuary. Below is the eagle on the south side with Philadelphia's main post office building in the background. Tracks underneath the post office building facilitated the expeditious loading and unloading of mail bags.

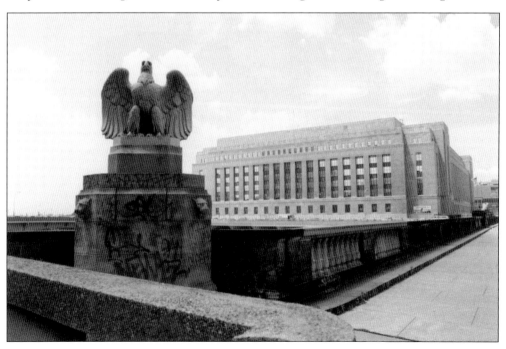

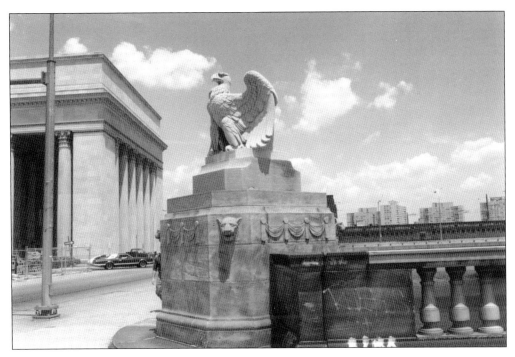

On the west side of the Market Street Bridge, the north eagle is seen above with 30th Street Station at left. Below is a photograph of the south eagle with the post office building in the background. By happenstance, a US Mail truck with eagle emblems on the side got into view for this photograph. All four eagles on the bridge have managed to retain their sharp beaks through the years.

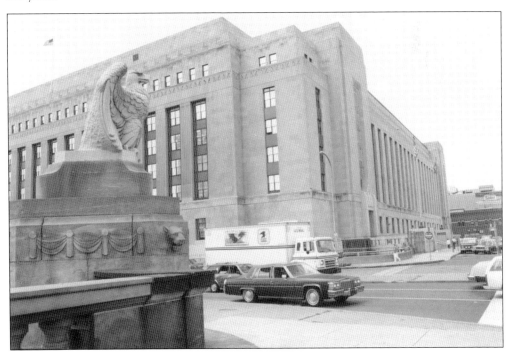

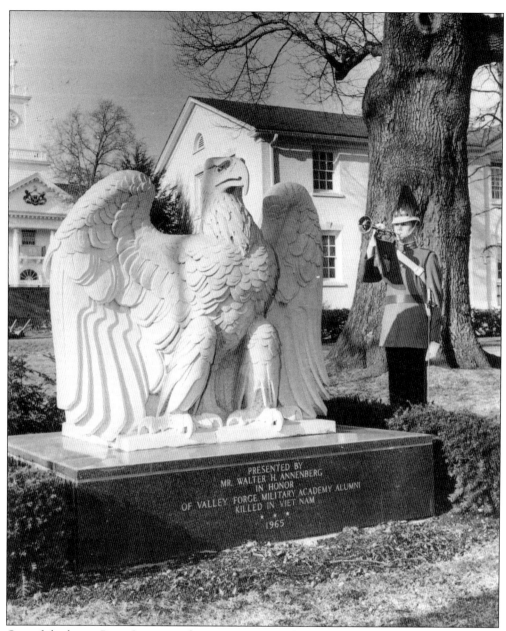

One of the larger Penn Station eagles was given to Walter Annenberg, who was a close friend of PRR president Allen Greenough. Annenberg was publisher of the *Philadelphia Inquirer*, the highest circulation newspaper in Pennsylvania, the home state of the Pennsylvania Railroad. He also founded *TV Guide* and *Seventeen* magazine. He originally placed the eagle on the front lawn of his home. Legend has it that his wife told him, "Either that eagle goes or you go!" Annenberg chose the better part of valor and decided to part with his beloved eagle, donating it to the Valley Forge Military Academy in Wayne, Pennsylvania. This photograph and the one on the facing page were taken by Lawrence Heinrich on the dedication day. (Courtesy of Joan Amundsen.)

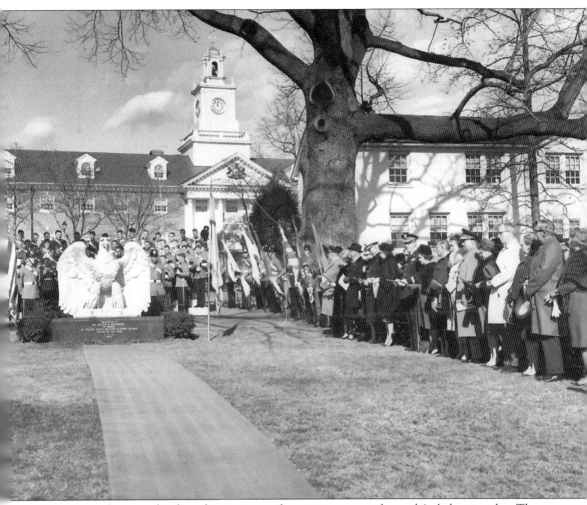

A full complement of cadets, dignitaries, and guests is seen at the eagle's dedication day. The academy honor guard, band, and alumni were present to pay tribute to this monument, which was dedicated to alumni killed in the Vietnam War. A red carpet was laid down leading up to the eagle. The large tree is no longer there, but the eagle remains in its original location between the chapel and Eisenhower Hall, looking out toward the parade field. (Courtesy of Joan Amundsen.)

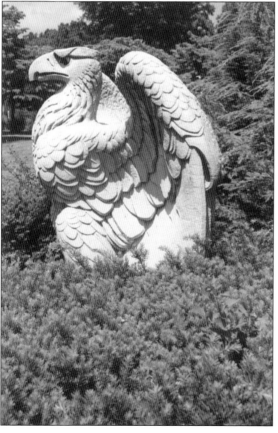

The shrubs on each side and behind the eagle, seen in the previous photographs, had grown quite large when these July 1990 photographs were taken. Above, a cannon looms in the foreground. At left, the eagle appears to be nicely preserved; however, the tip of its beak is missing. The parade field is to the left.

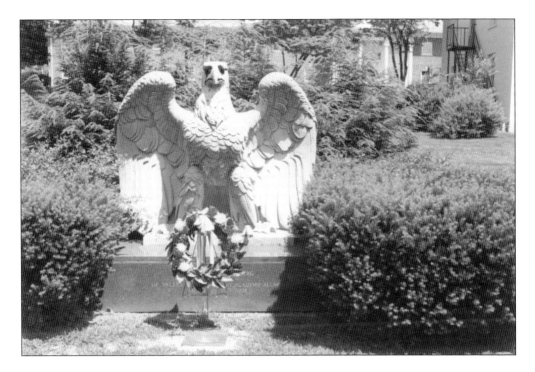

As seen above in July 1990, a wreath was placed in front of the eagle, with the shrubs nicely trimmed so as not to obstruct the view of the eagle and its base. The wording on the base appears in the photograph below. The monument was dedicated in 1965, when the Vietnam War was in its early stages. More cadets were probably killed in action before the end of the war in 1975.

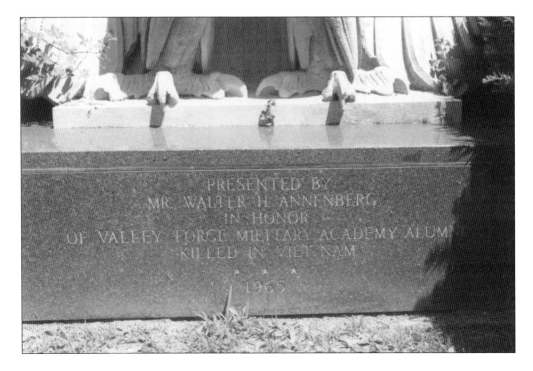

PRESENTED BY
MR. WALTER H. ANNENBERG
IN HONOR
OF VALLEY FORGE MILITARY ACADEMY ALUMNI
KILLED IN VIET NAM
★ ★ ★ ★
1965

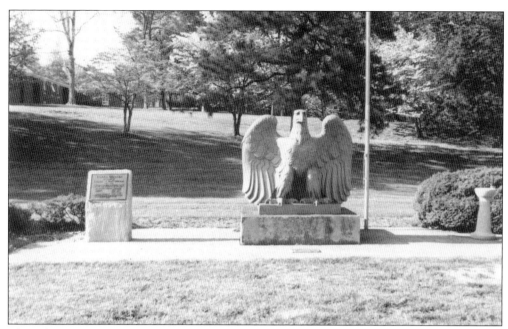

There does not seem to be any record of how one of the larger Penn Station eagles got to Hampden-Sydney College in Virginia, but it rests at the end of the Fulton football field in an area known as "Yank's Corner." The April 23, 1994, photograph above shows the eagle resting upon a low pedestal with a memorial plaque to the left. Seen below, that plaque, erected in 1967, honors Charles A. "Yank" Bernier, who served as football coach from 1912 to 1940.

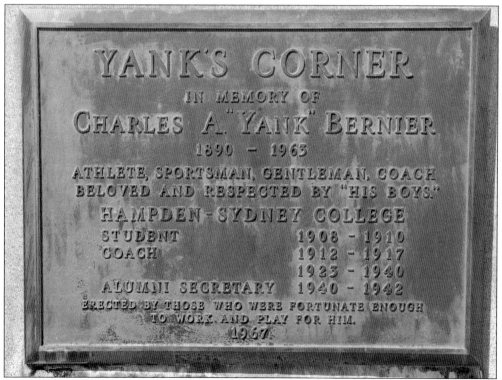

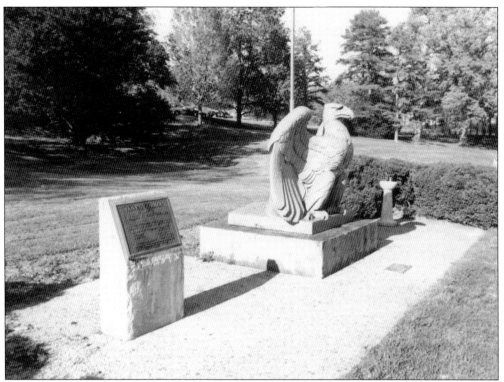

The April 23, 1994, photograph above shows a profile view of the Hampden-Sydney eagle. There is a small plaque imbedded in the cement in front of the eagle. Seen below, the plaque is dedicated to the college men who gave their lives during World War II. According to communications director Thomas Shomo, the football complex has for decades been referred to as "Death Valley," where the hope of victory of so many opponents has died. This explains the reference to death valley on the plaque.

A MEMORIAL TO
THE BRAVE YOUNG MEN WHO
WILLINGLY WENT FROM DEATH
VALLEY INTO THE VALLEY OF
DEATH DURING WORLD WAR II

WILLIAM A. LASHLEY, CLASS OF 1940

Of the 14 large Penn Station eagles, the most intriguing has to be the Smithsonian Institution's eagle, which is located outside the birdhouse at the National Zoo in Washington, DC. The Smithsonian has misidentified the eagle as being carved out of granite, while the quarry stone is actually marble. This April 23, 1994, photograph shows the eagle at ground level on the walkway to the birdhouse.

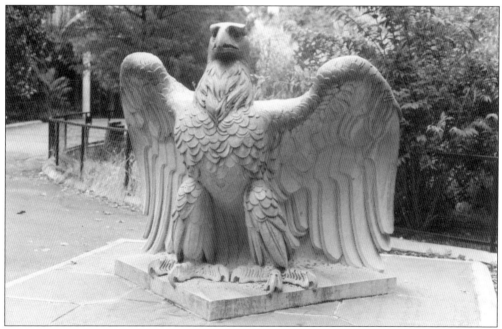

The Smithsonian eagle is one of two that rest upon a diamond-shaped base. It used to be on the Thirty-First Street facade of Penn Station, as shown on page 30. The other eagle on a diamond-shaped base is at Cooper Union, as seen on pages 89–91. It is unknown why these two eagles were placed on different bases than the others.

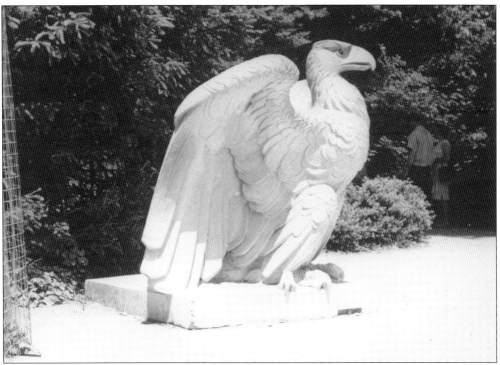

The above photograph shows a profile view of the Smithsonian eagle resting upon its diamond base. The April 23, 1994, photograph below shows a child climbing upon the eagle, a practice that was allowed at that time. Out of view to the right is a plaque giving information about the eagle. That plaque can be seen at the top of the following page.

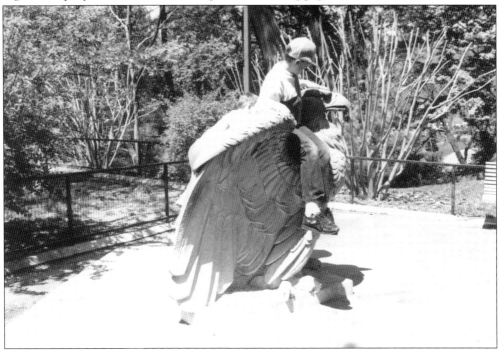

Pennsylvania Station Eagle

This eagle is one of several which once adorned the facade of Pennsylvania Station, a landmark of New York, N.Y., for over 53 years. In 1965, when the station was demolished to make way for Madison Square Garden and a new Pennsylvania Station, many people wanted the eagles, columns, and decorations from the building. The Smithsonian Institution was fortunate to receive this eagle from the Pennsylvania Railroad for the National Zoological Park.

Adolph A. Weinman, designer (1870-1952).
2590 kg (5700 lb), pink granite eagle

The last line on the plaque near the Smithsonian eagle identifies it as "pink granite eagle." As seen on the bottom of page 27, an early issue of the *Monumental News* identified the quarry stone as Knoxville marble. Don Curran, curator of the Gregory Museum in Hicksville, New York, examined the Hicksville eagle in 1993 and determined that it was marble and not granite.

Creating the Nation's first BioPark

National Zoological Park · Smithsonian Institution · Washington, D.C. 20008-2598

September 2, 1994

David D. Morrison
28 Azalea Court
Plainview, N.Y. 11803

Dear Mr. Morrison:

Thank you for your letter of June 27 and the enclosures. Our apologies for the delay in replying. Two days ago Tim O'Hearn of the Mineral Sciences Dept of the National Museum of Natural History made a field trip to examine our Penn Station Eagle. He confirms that it is marble, not granite but "cannot confirm whether it is Knoxville marble." He has samples of Knoxville marble and "they look different"

I think we must leave it at that pending further evidence. We will eventually amend the plaque to state that it is marble, possibly Knoxville (Tenn.) Marble.

I hope this belated response us a step towards solving the problem.

Sincerely,

Michael H. Robinson
Director

In 1994, the author wrote to the Smithsonian inquiring about the quarry stone of the eagle. On September 2, 1994, the director of the National Zoo, Michael H. Robinson, wrote this letter confirming that the eagle was carved from marble: "We will eventually amend the plaque to state that it is marble, possibly Knoxville (Tenn.) Marble." As of the writing of this book, the Smithsonian *Art Inventories Catalog* still lists the eagle as pink granite.

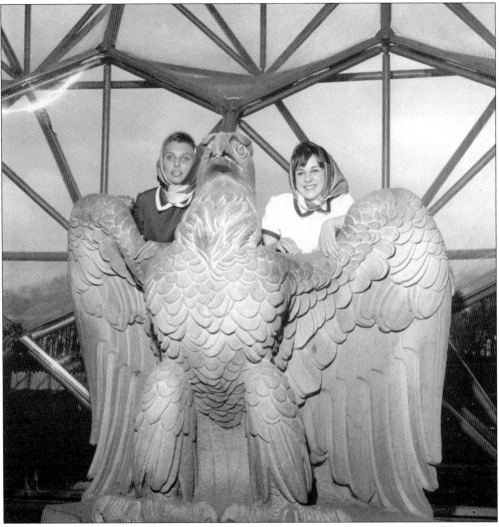

The Smithsonian eagle was shipped on loan to Canada to be displayed at Expo 67. The author's inquiries to the Smithsonian revealed that nothing was in their records pertaining to the loan. The author contacted the Canadian National Archives and was able to obtain this photograph of the Smithsonian eagle at Expo 67. (Courtesy of Canadian National Archives.)

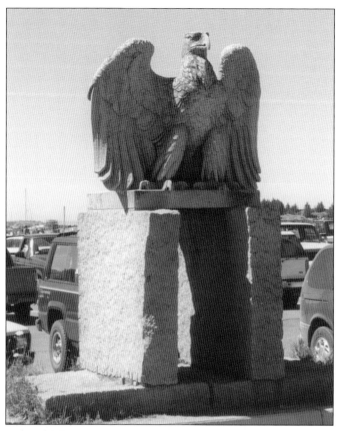

The final large Penn Station eagle is in Vinalhaven, Maine, as shown in these two photographs taken on July 22, 1997. This eagle is the most difficult to get to from New York City. It is over 400 miles away and is on an island, requiring a ferryboat ride to see it. The eagle was obtained by Vinalhaven under the mistaken belief that the quarry stone was Vinalhaven granite. Shortly after obtaining the eagle, they believed that the quarry stone was granite from Milford, Massachusetts, but decided to keep the eagle anyway as a tribute to the Vinalhaven stone-cutting industry. Now it is known that the quarry stone is actually marble. Still, the eagle does look nice on the main street in Vinalhaven.

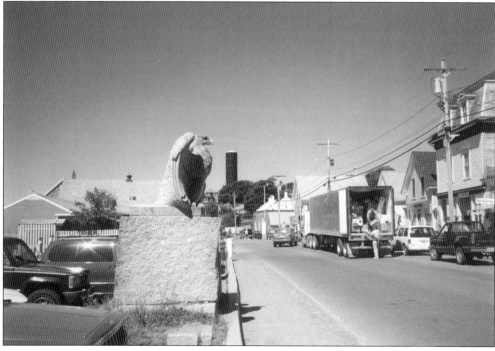

Eight

MOYNIHAN TRAIN HALL

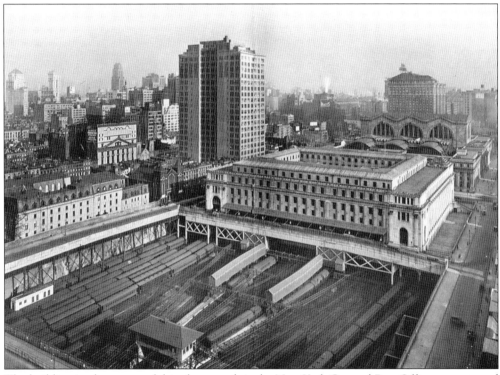

The building in the center of this photograph is the New York General Post Office, constructed in 1912. The tracks in the foreground go underneath the post office building and into Penn Station, which can be seen at right, beyond the post office building. The small building in the left foreground is Tower A, which controls all of the switches and signals west of Penn Station. In 1934, the tracks were covered when the post office annex building was erected between Eighth and Ninth Avenues. (Courtesy of the Library of Congress.)

NEW YORKS NEW POST OFFICE.

This photograph shows the New York General Post Office Building shortly after it opened in 1912. The view faces southwest. The front of the building faced the Eighth Avenue side of Penn Station. At track level, a mechanical conveyor system allowed mail bags to be transferred from the station platforms into the post office building. In 1982, it was named the James A. Farley Building. Portions of it are being converted into use as a new concourse for Amtrak, and that facility will be named the Moynihan Train Hall, after the late US senator Daniel Patrick Moynihan. (Courtesy of the Library of Congress.)

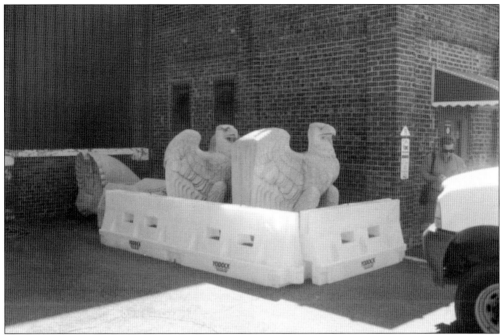

A Penn Station statuary group photograph in Ringwood, New Jersey, appears on page 37. The full statuary group was at Ringwood, including the eagles that abutted each side of the figures of Day and Night. As told on page 38, an attempt to get the statuary group into Penn Station in 1990 failed. In 2008, thoughts were given to placing the statuary group in a park next to the Newark Broad Street Station. New Jersey Transit then took possession of the statuary, had it professionally restored, and placed it in storage outside of its training facility building in Newark, where it rests today. The above photograph shows the two eagles being stored in Newark, and below is the author standing next to one of the eagles. The photograph below was taken by Carl Dimino.

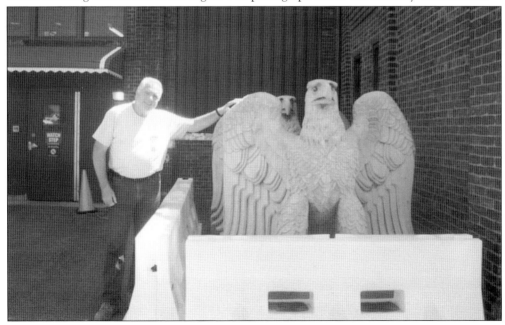

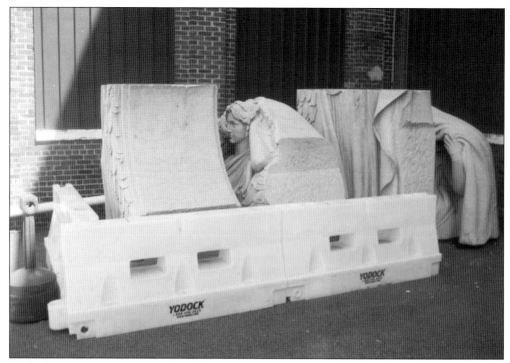

With plans to construct a new Amtrak concourse using part of the Farley Building, it was decided that the statuary should be returned to New York City and placed at the planned Moynihan Train Hall. Ground was broken on October 18, 2010, and the Moynihan Train Hall is expected to be completed in 2022, the same year that the Long Island Rail Road should start running trains into Grand Central Terminal. This statuary group should be returning to New York City to be installed someplace in the Moynihan Train Hall. The separated figures of Day and Night are seen above in Newark, and below is the top centerpiece of the statuary.

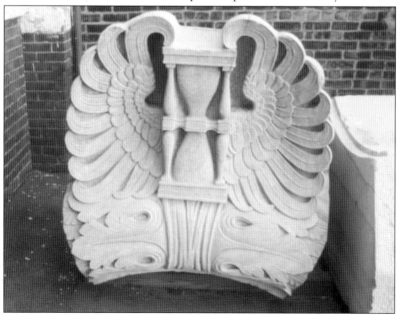

Albert Fritsch, a PRR mechanic who passed away in 1992, salvaged the head of a smaller eagle when Penn Station was being demolished. After decades in their backyard, Albert's granddaughter Margaret Flitsch contacted the author, and they got the ball rolling to bring public attention to this artifact. In the above May 5, 2011, photograph taken in the backyard, the eagle head is in the foreground, and in the background are, from left to right, granddaughter Margaret Flitsch, her aunt Mary, and her mother Margaret. The June 30, 2017, photograph below was taken when the women visited the Oyster Bay Railroad Museum where the eagle head was on display. The women affectionately named the eagle Albert.

During 2011, Albert was on display at the New York Transit Museum annex at Grand Central Terminal, as seen in this July 1, 2011, photograph; the author, at left, stands at the eagle head with David Dunlap, a reporter with *The New York Times*. Dunlap wrote that the author is "a railroad historian who may know more about the eagles of Pennsylvania Station and Grand Central Terminal than anyone else on earth. It is a rare scholar who could map the location of every known eagle salvaged from these buildings. Mr. Morrison is such a scholar." The museum's manager of exhibitions said of the author, "We consider him to be the world's leading expert on Penn Station eagles." Albert has also made appearances at the Railroad Museum of Long Island and, as seen in the next two photographs, the Museum of the City of New York. This photograph was taken by Margaret Flitsch.

The Museum of the City of New York celebrated the 50th anniversary of the passage of the New York City Landmarks Law by sponsoring an exhibition titled "Saving Place – 50 Years of New York City Landmarks." It was the destruction of Penn Station that led to the passage of the law, which was signed by Mayor Robert Wagner on April 19, 1965. As seen in these April 24, 2015, photographs, the eagle head Albert was a significant piece of memorabilia on display. After the exhibit closed on September 13, 2015, Albert was returned to the Oyster Bay Railroad Museum, where it is currently on display. Maybe someday in the future, Albert will be put on display inside the Moynihan Train Hall.

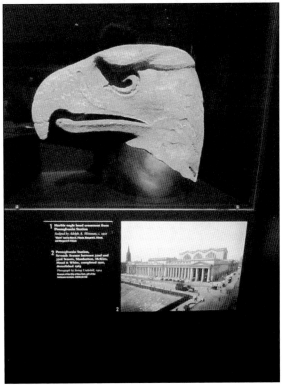

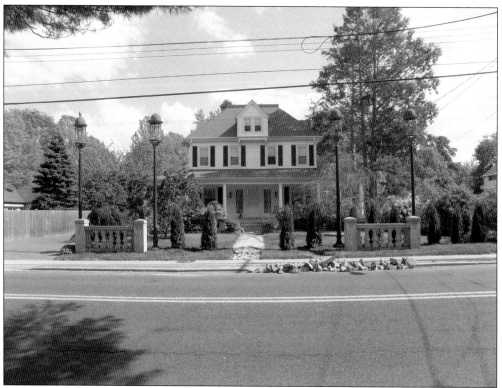

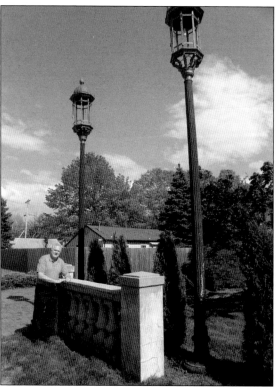

Several unique remnants from the old Penn Station are located in Eatontown, New Jersey, as seen in these September 22, 2014, photographs. Above, two cement balustrades that used to be on the roofline of the building are situated on either side of the walkway leading up to the house. On each side of the balustrades are streetlamps that used to be outside the building at street level. At left is a photograph of the author standing next to a balustrade with two of the lamps in view. Maybe someday, these remnants will be returned to New York and placed at the Moynihan Train Hall. The photograph at left was taken by Diane Morrison.

BIBLIOGRAPHY

Amundsen, Joan. "Where Are the Penn Station Eagles?" *Railroad*, May 1972, 36–39.

Ballon, Hilary. *New York's Pennsylvania Stations*. New York, NY: W.W. Norton & Company, 2002.

Belle, John, and Maxinne Leighton. *Grand Central: Gateway to a Million Lives*. New York, NY: W.W. Norton, 2000.

Bilotto, Gregory, and Frank DiLorenzo. *Building Grand Central Terminal*. Charleston, SC: Arcadia Publishing, 2017.

"Bronxville Eagle Returns to 1st Nest." *Journal News*, October 19, 1999.

Cohen, Stefanie. "Talon Search Leads to Celebrated Iron Eagle." *Newark Star Ledger*, July 24, 2005.

David, Patricia. *End of the Line*. New York, NY: Neale Watson Academic Publishing, 1978.

Diehl, Lorraine B. *The Late, Great Pennsylvania Station*. New York, NY: American Heritage Press, 1985.

Dunlap, David. "After Half a Century, a Penn Station Eagle Returns." *The New York Times*, July 5, 2005.

———. "Reclaiming Day and Night, Memories in Marble." *The New York Times*, February 9, 1998.

Gearty, Robert. "Eagle-Eyed LIRR Man Has an Aerie Obsession." *New York Daily News*, March 30, 1997.

Halbfinger, Caren. "Eagle Comes Home to Roost." *Journal News*, April 29, 2004.

———. "Historic Eagle Statue Coveted." *Journal News*, January 10, 2004.

———. "Man Finds Missing Statue Across Area." *Journal News*, May 13, 2003.

Lane, Wheaton J. *Commodore Vanderbilt: An Epic of the Steam Age*. New York, NY: Alfred A. Knopf, 1942.

Leavy, Michael. *The New York Central System*. Charleston, SC: Arcadia Publishing, 2006.

Lee, Denny. "A Cast Iron Eagle Seeks an Aerie at Grand Central." *The New York Times*, January 11, 2004.

MacFarquhar, Neil. "Rara Avis: An Iron Eagle Returning to City Roost." *The New York Times*, June 20, 1997.

Marshall, David. *Grand Central*. New York, NY: McGraw-Hill Book Company, 1946.

Messer, David W., and Charles S. Roberts. *Triumph V: Philadelphia to New York 1830–2002*. Baltimore, MD: Barnard Roberts and Company, 2002.

Middleton, William D. *Grand Central: The World's Greatest Railway Terminal*. San Marino, CA: Golden West Books, 1977.

———. *Manhattan Gateway: New York's Pennsylvania Station*. Waukesha, WI: Kalmbach Publishing Company, 1996.

Moore, Peter. *The Destruction of Penn Station*. New York, NY: Distributed Art Publishers, 2000.

Morrison, David D. "The Railroad Eagles of New York." *Railfan & Railroad*, Nov. 2010, 38–43.

———. *The Cast Iron Eagles of Grand Central Station*. Plainview, NY: Cannonball Publications, 1998.

———. *Long Island Rail Road Stations*. Charleston, SC: Arcadia Publishing, 2003.

———. *Sunnyside Yard and Hell Gate Bridge.* Charleston, SC: Arcadia Publishing, 2016.

Powell, Kenneth. *Grand Central Terminal: Warren and Wetmore.* London, UK: Phaidon Press, 1996.

Roberts, Sam. *Grand Central: How a Train Station Transformed America.* New York, NY: Grand Central Publishing, 2013.

Robin, Joshua. "One True Eagle Scout." *Newsday*, June 29, 2003.

Robins, Anthony W. *Grand Central Terminal: 100 Years of a New York Landmark.* New York, NY: Stewart, Tabori & Chang, 2013.

Schlichting, Kurt C. *Grand Central Terminal: Railroads, Engineering and Architecture in New York City.* Baltimore, MD: John Hopkins University Press, 2001.

———. *Grand Central's Engineer.* Baltimore, MD: John Hopkins University Press, 2012.

Warikoo, Niraj. "Eagle Returning to Grand Perch." *Newsday*, June 20, 1997.

Westing, Fred. *Penn Station: Its Tunnels and Side Rodders.* Seattle, WA: Superior Publishing Company, 1978.

INDEX

DISCOVER THOUSANDS OF LOCAL HISTORY BOOKS FEATURING MILLIONS OF VINTAGE IMAGES

Arcadia Publishing, the leading local history publisher in the United States, is committed to making history accessible and meaningful through publishing books that celebrate and preserve the heritage of America's people and places.

Find more books like this at
www.arcadiapublishing.com

Search for your hometown history, your old stomping grounds, and even your favorite sports team.

Consistent with our mission to preserve history on a local level, this book was printed in South Carolina on American-made paper and manufactured entirely in the United States. Products carrying the accredited Forest Stewardship Council (FSC) label are printed on 100 percent FSC-certified paper.

MADE IN THE USA